Harvey
BREVERMAN

Harvey
BREVERMAN

Humanist Impulses
Selected Paintings, Drawings, Prints

UB Art Galleries: UB Art Gallery and UB Anderson Gallery, Buffalo

EXHIBITION DATES
UB Art Galleries
October 1–December 31, 2004

CREDITS
Curator: Sandra Firmin
Director: Sandra H. Olsen, PhD
Design: Kelly Myers, Quiller & Blake Advertising
Printing: Freudenheim/United Graphics, Buffalo, NY
Editor: Meghann French
Photography credits:
 Biff Henrich
 Don Weigel
Typeface: Helvetica and Garamond
Paper: 130# Garda Art Silk Cover and
 100# Garda Art Silk Text

CONTRIBUTORS

Sigmund Abeles, Artist and Professor Emeritus,
 The University of New Hampshire
Robert J. Bertholf, Charles D. Abbott Scholar of
 Poetry and the Arts, The Poetry Collection,
 University at Buffalo
Nancy E. Green, Senior Curator, Prints, Drawings,
 and Photographs, Herbert F. Johnson
 Museum of Art, Cornell University
Bruce Jackson, SUNY Distinguished Professor
 and Samuel P. Capen Professor of
 American Culture, University at Buffalo

Poem: Robert Creeley, Distinguished Professor of
 English, Brown University

Republished:
Raymond Federman
 On the occasion of "The Human Presence"
 at the Nardin Galleries, New York, 1980
Sylvia A. Herskowitz
 Director, Yeshiva University Museum
 On the occasion of "Mystery of a Prayer Shawl
 Series" at Yeshiva University Museum, 1997
Stephanie L. Taylor
 Department of Art, New Mexico State University
 On the occasion of "The Nightworks Series:
 40 Works on Paper" at Indiana University
 School of Fine Arts Gallery, 2001

University at Buffalo Art Gallery
College of Arts and Sciences
201A Center for the Arts
Buffalo, NY 14260

University at Buffalo Anderson Gallery
Martha Jackson Place
Buffalo, NY 14214

http://www.artgalleries.buffalo.edu/

ISBN 0-9748932-2-6

University at Buffalo
The State University of New York

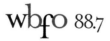

wbfo 88.7

The exhibition and catalog have been made possible by generous support from the University at Buffalo: College of Arts and Sciences, College of Arts and Sciences Publication Subvention Fund, Division of University Advancement, Institute for Jewish Thought, UB Alumni Association, and WBFO 88.7 FM.

UB Art Gallery is supported with funds from the College of Arts and Sciences, the Visual Arts Building Fund, the Seymour H. Knox Foundation Fine Arts Fund, and the Fine Arts Center Endowment.

UB Anderson Gallery is supported with funds from the Office of the Provost and Executive Vice President for Academic Affairs, the College of Arts and Sciences, the Anderson Gallery Program Fund, and the UB Collection Care and Management Endowment Fund.

TABLE OF CONTENTS

LENDERS TO THE EXHIBITION

Albright-Knox Art Gallery, Buffalo, NY

Harvey Breverman

Phillip and Judy Brothman, Williamsville, NY

Murray and Barbara Brown

Pauline and Richard Brummer

Dr. Paul and Joyce Chapnick

Mark Chason and Mariana Botero Chason

Mr. and Mrs. William M. E. Clarkson

Kenneth and Antoinette Dauber

Dicke Collection

Martha and David Dunkelman

Dr. and Mrs. Marshall Fagin

Fine Arts Museums of San Francisco, CA

Mr. and Mrs. Daniel Fogel

Dr. and Mrs. Joseph Fradin

Julie Freudenheim and Spencer Feldman

Mitch Flynn and Ellen Goldstein

James and Katherine Goodman

Mr. and Mrs. Richard Gordon, Buffalo, NY

Carl and Ruby Green

John W. and Pamela M. Henrich, Eden, NY

Kalamazoo Institute of Arts

Dr. Leonard and Judith Katz

Kennedy Museum of Art, Ohio University

Betty and Irving Korn

Dr. and Mrs. George R. Levine

Ginger and David Maiman

Annette and Joseph Masling

Paul and Janet McKenna

Gerald C. Mead Jr.

Memorial Art Gallery of the University of Rochester

Joseph and Rena Merrick

Michael Morin, Celtic Press

National Academy of Design, New York

Frederic P. and Alexandra B. Norton

Mr. and Mrs. George Pearlman

Dr. and Mrs. Michael Ram

Kevin and Joanna Ransom

Morton G. Rivo, Mill Valley, CA

Ruth W. Setters

Sue and Gerald Strauss

Mrs. Harrison Swados

Elizabeth and Peter Tower

University at Buffalo Foundation

Poetry/Rare Books Collection, University Libraries,
 University at Buffalo, the State University of New York

Howard L. Yood

Private Collections

FOREWORD & ACKNOWLEDGMENTS

The University at Buffalo Art Galleries are honored to present this exhibition for SUNY Distinguished Professor of Art Harvey Breverman. The title of the exhibition— *Humanist Impulses, Selected Paintings, Drawings, and Prints*—reflects Breverman's lifelong interest in learning, through visual depiction, about the people and objects that surround him.

Even a cursory review of his extensive, but greatly abbreviated, bibliography will astound the reader. Breverman has been invited to hundreds of International Print Biennales, where his command of the medium, combined with intriguing subject matter and composition, was recognized by Purchase Awards at almost every exhibition. The list of periodicals, essays, and brochures provides a testament to Breverman's extraordinary career, but the chronology reveals more clearly his immersion in all aspects of an art practice sustained by boundless energy and dedication. He has served as panelist, juror, lecturer, and resident artist; exhibited in solo and group exhibitions too numerous to list; and worked collaboratively with world-renowned print shops, master printers, visiting scholars, artists, and writers. A faculty member of the UB Art Department since 1961, Breverman was recognized nationally for his lifelong dedication to teaching by the College Art Association in 2003, when he was given the prestigious Distinguished Teaching of Art Award.

All of these activities and interactions hone the diverse technical skills required by the variety of media between which Breverman moves effortlessly. They also bear witness to the challenging perfection he demands of himself. In turn, Harvey Breverman challenges each of us. For, above all, he is a teacher and mentor who believes that art can lead to deep meditations on the mysteries and wonders of the human experience.

More than two hundred works of art fill nearly all of the university's two exhibition spaces—the UB Art Gallery and the UB Anderson Gallery. Only an exhibition of this size could adequately represent Breverman's mastery of various media, including more than one hundred large-scale paintings and drawings from the late 1970s and a comprehensive survey of more than ninety prints spanning four decades. The exhibition design deliberately rejects a retrospective format and instead thoughtfully focuses upon the serial nature of Breverman's work, including the powerful Nightworks series never shown previously in Buffalo.

Among many people who made this exhibition and catalog possible, I am most grateful to Harvey Breverman for his diligence on all phases of this exhibition and for entrusting our professional staff with this large body of work. I would also like to thank

his wife, Deborah, for her support. The enormous task of organizing this exhibition, catalog, and panel was accomplished by Sandra Firmin, curator of the UB Art Gallery, Center for the Arts, in close collaboration with the artist. We are very grateful to Sandra for her insights throughout the exhibition's planning and for her intelligent interview, which informs this important and largest exhibition for one of Buffalo's most prominent artists and one of the University at Buffalo's most distinguished faculty members.

Special thanks are due to the catalog essayists, Robert Bertholf, Nancy Green, and SUNY Distinguished Professor Bruce Jackson; to contributing writer Sigmund Abeles; to poet Robert Creeley; and to those writers who agreed to have their texts republished: Raymond Federman, Sylvia Herskowitz, and Stephanie Taylor. We also thank panelists Douglas Dreishpoon, Nancy Green, Endi Poskovic, Douglas Schultz, and Stephanie Taylor, and the Buffalo and Erie County Historical Society for cosponsoring the panel discussion.

The UB Art Galleries are extremely grateful to the many institutional and private collectors who loaned artwork from Canada, California, Florida, Michigan, New York and Ohio. The exhibition and catalog have been made possible by generous support from Quiller and Blake Advertising and the University at Buffalo, including the College of Arts and Sciences, the College of Arts and Sciences Publication Subvention Fund, the Division of University Advancement, the Institute for Jewish Thought, the UB Alumni Association, and WBFO 88.7 FM.

Thanks are due to graphic designer Kelly Myers of Quiller and Blake Advertising, editor Meghann French, photographers Biff Henrich and Don Weigel, Robert Freudenheim for the catalog printing and production, and Domenic Licata and Arzu Ozkal Telhan for the Web site design. The exhibition and all related activities would not have been possible without the commitment and patience of the professional and support staff of the UB Art Gallery, Center for the Arts: Kristin Riemer, public relations/development officer; Patrick Robideau, preparator; Dwayne Sylvester, gallery manager and preparator; Kitty Marmion, administrative assistant; and at UB Anderson Gallery: Mary Moran, director; Ginny Lohr, coordinator of education; Bob Scalise, gallery manager and preparator; Nancy Wulbrecht, registrar; Paul Wilcox, maintenance assistant; and a legion of work-study students and museum studies interns.

At the university, I wish to thank President John B. Simpson, Provost and Vice President for Academic Affairs Satish K. Tripathi, and College of Arts and Sciences Dean Uday Sukhatme for their generous support of the UB Art Galleries.

— Sandra H. Olsen, PhD

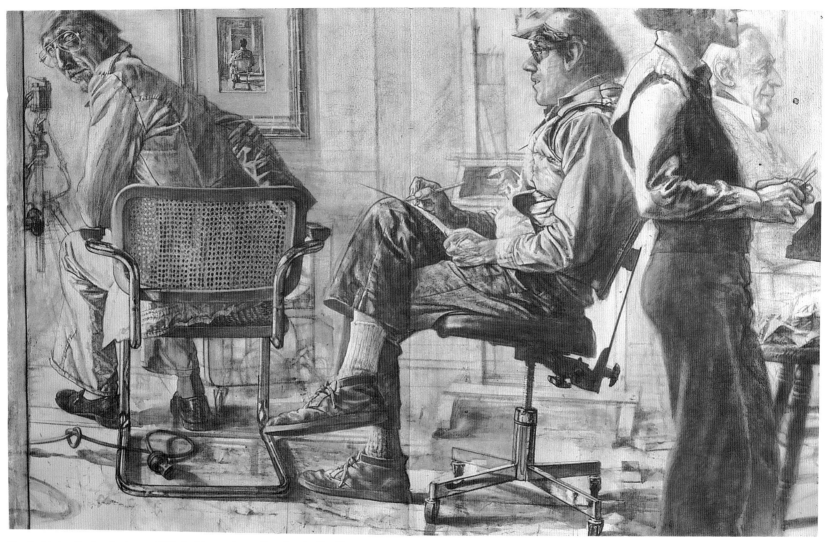

Fig. 1 *Interior: The Drawing Lesson*, 1985, Pastel, sanguine conté, and wash, 48 x 76

HARVEY BREVERMAN ON CANVAS AND ON PAPER: REVEALING THE INVISIBLE

NANCY E. GREEN

For nearly six decades Harvey Breverman has engaged and perplexed us with a conundrum. Labeled a realist artist, he wears this mantle uneasily, providing his viewers with uncountable layers of meaning and complexity, a reflection of the complication of our own selves. His figures are generally anonymous, yet they reflect a bit of every one of us, which is what makes them so appealing but also rather frightening. Sometimes he incorporates formal and symbolic Jewish ceremonial objects, which can be translated literally or applied to a more universal spiritualism. And frequently, his subjects are as much about their absence as their presence. He mingles the seen with the unseen, the tangible with the intuitive and emotional, offering an answerless enigma that strikes at the core of our own questioning existence. It is a reality far beyond the ken of the so-called reality depicted on twenty-first century television. There is experiential depth here that reflects the daily confrontation with life's triumphs and tragedies, as well as the routine process of just living.

In some ways it is unusual that Breverman arrived at this nonconforming point so early in his career, assiduously pursuing an elusive muse that would intrigue him for more than half a century. Sometimes the answers to his universal queries seem imminent, and yet he—and we—know this is never truly possible. Peel back any layer of his compositions and what is revealed is only another equally gauzy layer, and yet the search never seems futile, probably because it is an interactive dialogue between the artist, the subject, and the viewer—a philosophical discussion that spawns more questions in the endless endeavor to know the unknown.

What stimulates Breverman's work can be surmised by his subject choice. He came onto the art scene in the early 1960s, so it is not surprising that social issues worked their way into his compositions. But his art never seems dated; he goes beyond the mere facts and relates our present with our past, both historically and in his art-historical references. This lends each work a timelessness that segues seamlessly into the present. This Ariadne's thread of memories leads to the stop-time present and then on into the future, effortlessly connecting time in a surreal manifestation.

But none of this explains why, as abstract expressionism gave way to pop art, he chose a different route, an introverted style that gives a passing nod to photorealism but one that has none of the bland impersonality of those sterile replications. In the 1960s and 1970s, abstract expressionism was supplanted by pop art, op art, and photorealism. The virtuosity that each movement displayed was accomplished, but created no emotional connection between artist and audience. Though in style Breverman comes closest to the feel of photorealism, he goes beyond this by allowing the element of human interconnection to exist in his work. His subjects live, breathe, suffer, triumph. They are survivors who daily confront the intricate mystery of everyday life, and they are grounded in the centuries of the Old Masters. Breverman uses the light and chiaroscuro of his predecessors with a directness and emotional charge that is both confrontational and revealing.

Looking at this artist, whose work matured in the heady days of the 1960s, it is surprising that he did not conform to the prevalent styles of the time. More convincingly, Breverman fits in with the social realists working in America and Britain at the time, artists such as Jack Levine, Joseph

Hirsch, R. B. Kitaj, and Richard Hamilton. This group raised questions about the war in Vietnam, civil and gay rights, human sexuality, and the growing expectations of a burgeoning post–World War II middle class, raised with expectations never imagined by previous generations. The contrast of this new comfort with the growing unease of the political and societal milieu complicates and intensifies the work of these artists. But Breverman is never shy about head-on confrontation, and his many series are forthright attestations of his concept of both the larger and smaller issues and what is at stake.

Breverman chose a different tack from many of his contemporaries, focusing on an equally compelling motif of the sixties generation—the search for self, an inner exploration of the spiritual nature of humanity and its ability to both alienate and rub along in nearly simultaneous motion. Though his subjects are usually friends, family, and colleagues, they stand in for the universal Everyman, with probing, unanswered questions, hopes, and dreams. Looking at his art is like looking in a mirror—a device Breverman uses adroitly in many of his images, harking back to the manner in which Jan van Eyck used the mirror in the *Arnolfini Wedding* (1434) to expand the visible world of the canvas to include the unseen, outside the painting's perimeters.

In an examination of Breverman's oeuvre it is his adeptness and surety of touch in a variety of media, from pastel to oil painting to printmaking, that mark him as a consummate craftsman, at ease with all the tools of his trade. It is this ease that enlivens his surfaces, seamlessly melding his subject with the medium. His artistic development has not been a linear one; rather, it feels like the ripples a stone creates when it hits water, concentric circles moving out from a central core and swirling back in on themselves. It is not possible to say such-and-such work evolved into or

from another—the progression is one that moves both forward and backward, listening to the work of the past while generating those of the future, and moving back again. The results are series that span decades. Breverman can comfortably return to topics and see them anew, bringing a freshness and sense of regeneration to his compositions. As a lifelong teacher, Breverman knows the value of cumulative knowledge, both personal and historical, passing it back and forth between his compositions in a smooth rhythm.

As a draftsman, Breverman excels. It is this talent that may cause some viewers to dub him a realist painter. He carefully exposes each fold, each stitch in the seam, each facial wrinkle—and yet this precise attention to detail is often shown simultaneously in the same image with less exact areas, such as a ghostly suggestion of a table leg or an ankle, sometimes a spectral visage that seems to float with no corporeal substance. He captures the way we see, taking in some details but never all, allowing many to remain on the periphery, insubstantial yet not inconsequential. In a work such as *The Dealer and the Cardinal* (1988; plate 10), the seated figure seems to be sharing a lively conversation with the inanimate religious statue. The accoutrements to the scene—the open book on the floor, the stacked framed pictures, the sculpted bust paralleling the dealer's profile—appear confounding. What do these objects mean, both cumulatively and individually? Consider *Two Jews in Tangier I* (1981), another large pastel. Breverman and a young man sit in profile, one behind the other, eyes forward, looking off to the left of the paper. The objects on the table and the floor provide no clues to the scene before us; the figures remain calm though disconnected from each other, oblivious. If they were on a public conveyance, something their positions suggest, this disconnect would be understandable. But they are in a domestic interior, and yet

they seem to be unrelated on any level. Each viewer brings his or her own narrative to the scene, creating a thousand and one tales for an image that initially seems completely innocuous and benign but whose psychological depths grow the longer it is viewed.

This group of large pastels, done over the decade of the 1980s, yields other surprises as well. In *Mélange* (1984; fig. 9) many of the figures are recognizable—portraits straying almost into caricature—and yet it feels like an ordinary scene, a group of people convening before a staff meeting, catching up with each other, chatting. What is striking here is the relaxed atmosphere coupled with the confrontational gaze of two of the figures—particularly the disturbingly direct gaze of the philosopher and writer Michel Serres, who looks out at us with a touch of humor. Once again, Breverman's audience becomes a participant, a vital component to the composition. We are riveted by Serres's attention and, like a deer caught in the headlights, there is no turning away.

In *Interior: The Drawing Lesson* (1985; fig. 1) this engagement becomes a bit disconcerting. While the artist, in profile, seems to be drawing something or someone off to the left, a man turns in his chair to stare at us, challenging. Even more disconcerting is the picture on the wall. At first it seems to be a mirror, but it can't be since it does not reflect ourselves viewing the drawing. Instead it shows a seated figure with his back to us— the supposed subject of the artist's drawing? The surreal quality is enhanced by the two figures at right, who seem to be performing a different tableau altogether. Both men are in profile; one is lightly drawn, almost ghostlike, while the foreground figure is cut off by the canvas edge below the knees and at ear level, flattening him out to a cutout figure. Who are these men? What are they doing in this studio? And, ultimately, despite the distinctly modulated details, what is really real? We can almost feel

Fig 2. *Bruce Jackson*, 2003, Pastel and conté, 22 x 30

the chrome of the chair, the raised caning of the chair seat, the scuffmarks on the shoe, the minute hairs of the eyebrows. But there is a dreamlike quality to the scene, as if these figures have stepped out of time to play a role.

The sheer size of these drawings is daunting. This alone would create a confrontation with the viewer, but Breverman's adept use of the pastel and conté crayon, softening certain details while emphasizing others, heightens our perception of the interrogative nature of these works. Many details are left in an ephemeral stage, and disparate objects are combined within the composition; questions linger and resolution seems improbable, but they entice us with their suggestive hint of a compelling narrative.

The Empty Jacket series (plates 14 & 15) is an equally intriguing document, but in a more personal way. With its suggestion of carefully constructed folds, zippers, buttonholes, and stitching, the jacket seems to

breathe a life of its own, separate and complete, neglectful of the wearer. In some cases the wearer becomes completely anonymous, viewed from the neck down, or completely disappears from view, leaving the jacket to float in its own space. We are really looking at a portrait of a piece of clothing, an article worn daily in cold weather, in all its safe familiarity and comfort, a separate entity with its own personality. As such, it becomes a second skin, protective and warm, reflecting much about the anonymous wearer.

A similar series, Mystery of a Prayer Shawl (plates 16–18), has no real beginning or end for Breverman—"the tallit persists with ever increasing drama, a surrogate of memories, dreams, and imaginings."[1] Where the Empty Jacket series is a secular approach to the comfort of being enfolded in cloth, the wrapping of the tallit as the initial act of praying is symbolic of a deeper encasement, the cloth representative of God cloaking himself in light. By donning such a garment, the wearer takes on a spiritual commitment. In these works, the eloquence of Breverman's draftsmanship is unrestrained; shown from behind, as it would have been viewed in the synagogue, each drape and fold, each delicate fringe and stripe, is handled with loving attention. As in many of the works in the Empty Jacket series, these portraits are faceless, infused with the distinct personality of the wearer, who remains anonymous. These shawls have a haunting presence that affects the viewer and artist alike. As Breverman has said, "I use a prayer shawl . . . as a metaphor for exhilaration, suffering, joy, fear—all sorts of things—and it can't leave me."[2] This effect is a universal one.

Breverman often uses himself as model, and in The Dandy II (1986) and In the Studio (Palette) (1988) we get two different self-interpretations. The dandy lifts his chin and opens his lips as if to expound, diffidently holding a cigar in his right hand, and there is an inkling that this may be tongue in cheek. But In the Studio shows a much less refined figure—shirt crumpled, stained hands gesturing; a portrait of the artist at work. In both, the conté crayon serves Breverman well, used adroitly to capture the emotions of the model. While seemingly sketches, both portraits ring true, elucidating two parts of a complex personality.

Breverman's portraits capture more than just surface appearance. In Bruce Jackson (2003; fig 2.), he uses a device seen frequently in the etchings of Antony van Dyck—the sitter's face is rendered with great felicity but the body is merely sketched, fading away with just a few strokes of the crayon. The other details provided, such as the sketches of the hands at the left, feel like a remarque, a small sketch off to the side that reads like an afterthought to the main issue, added as an extra piece of information to enhance our comprehension.

In his portrait Michael Parker (2003), Breverman retains the sketched pentimenti to the left of the head, as if the sitter had suddenly changed position. The intensity of the drawing is reminiscent of Käthe Kollwitz's style, dense and emotional. Here, unlike in Bruce Jackson, the crayon marks are denser, rubbed to a soft sfumato, capturing the thoughtfulness of the model gazing off to the side, lost in his own world. The humor, the pain, the cares that form each life are clearly visible on his models' faces. This is what makes them so real, so knowable, so accessible.

The Beckett series, done during the same decade as the large pastels, are elegantly, and often humorously, drawn. In Beckett in Venice (1984; plate 11), the writer confronts a carnival-masked figure—probably Breverman himself—whose mask, with its exaggerated beaked nose, reflects Beckett's own visage. He looks perplexed at the sight, as if confronting something he had never known about himself, or perhaps meeting a twin he didn't know he had. In Beckett as a Matador (fig. 15) from

the same year, he seems to smile inwardly as he nonchalantly puffs on a cigarette: a few minutes of calm before engaging in combat with the bull. Beckett as a matador seems perfectly plausible here; he wears the clothes well, with an attitude of pride. His is a face that has seen and thought much and yet can be amused at the slightest provocation, even if it is amusement at himself. It is an ageless face that in *Beckett and Baseball* (1986; plate 12) shows the determination of righting a wrong as Beckett confronts an umpire. While whimsical in conception, in none of these scenarios does Beckett seem out of place. Breverman, with a sense of humor, has shown us this Godot-like writer as very human.

Breverman addresses many of the same themes in his paintings as in his drawings; though they are frequently connected, the movement is a fluid one, as the artist segues lithely between media. In *Interior of an Exterior: Avignon I* (1980; fig. 3), the shallow space embraces the lone figure with his back to us, head bowed. Is he reading? Sleeping? Praying? Facing him is a four-paned window, each pane reflecting a disparate scene, a disconcerting and dislocating environment. The details are all beautifully rendered—the carved acanthus leaves that decorate the building, the reflected wrought-iron railing, the slack back of the canvas chair. The figure does not feel at one here—with his back to the viewer, he isolates himself, removing himself from our gaze, and we feel this removal as if the figure has mouthed a verbal rejection. Similarly, in *Interior: The Studio VI (Homage)* (1987; fig. 13), the figures' gestures are as eloquent as words. We feel that our presence is questioned, even undesirable, and yet we have already witnessed the scene. Here, as in many of his works, Breverman lovingly renders objects that seemingly have no meaning to the context, which also proves disconcerting—the meaning becoming more elusive the longer we look. This is intentional,

addressing the mystery of how and why we occupy space and what shares that space with us. This ability to capture this feeling on canvas is almost cinematic, like a stop-frame in which we vainly search for solutions to the whole enigma of life. In Breverman's work, presented as narrative, interconnected tales that stretch over years in the telling, memory becomes an important part of the story; we see his characters age and go through transitions and, as with any good story, we become transfixed by the tale and need to know the ending, so we faithfully follow the twists and turns of the telling to its completion.

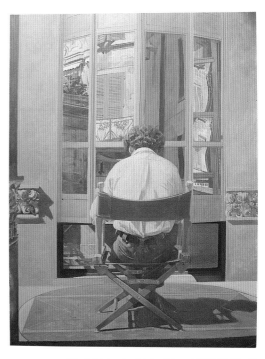

Fig. 3 *Interior of an Exterior: Avignon I*, 1980, Oil, 66 x 54

Breverman began making portraits in the 1960s and continues examining the individual mystery and vagaries of humanity to this day. The figure is always much more clearly defined than the illusory space that surrounds his sitters, a reflection of the world in which, though the milieu may change, the self remains stable. To emphasize this, Breverman often uses the same portrait in different scenarios, walking us through episodes of the figure's life in a tangential narrative that tells us as much about the artist as about the sitter. Though the settings are frequently exotic, such as Jerusalem, Tangier, or Prague, location is in fact not always relevant to our understanding.

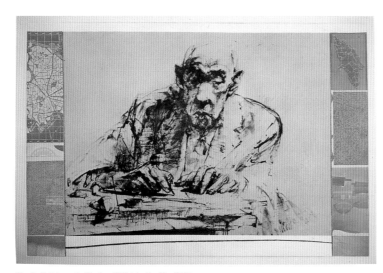

Fig 4. *Dutchman in Rhodes*, 1972, Intaglio, 23 x 34 ¾

Breverman's painting style is closely linked to his work in pastel and conté crayon in its fluid brushwork and in his ability to capture subtlety and nuance. Using scumbling and a palette knife, he creates surfaces that are lustrously appealing, a tactile tribute to memory, emotion, and history.

One of the most remarkable—and poignant—of the artist's series is Nightworks (plates 19–30), a group of pastels from the past fifteen years in which he enshrines intellectuals against a Holocaust backdrop, a backdrop that harnesses the figure with threadlike tentacles to a ghostly past, a fusion that lends an eerie, dreamlike quality to the work. Here, unlike in many of his other works, the background is often a recognizable place, such as Sarajevo or Warsaw. The intensity of this series is propelled by the dense, dark strokes of the drawn lines, the rubbing and blurring that enhance the feeling of suffering and sadness, like looking into the depths of the men's souls. The density of the layers, with their references to religious texts and ceremonial objects, cause the surface to fluoresce, like a beautifully illuminated

manuscript, while at the same time raising questions. Is there redemption? It is another question that has no clear answer.

Not surprisingly, a constant through most of his career has been Breverman's engagement with prints. Closely allied with his work in drawing and pastel, he approaches his graphic work with the same adept attention to detail and emotional underpinnings. Breverman has made prints since the early 1960s. His first etching was made in 1962 when he learned the process after being asked to teach it. He studied prints in the Library of Congress and Metropolitan Museum collections, adapting his innate skill as a draftsman to the etching plate. Steeped in the rich tradition of the Dutch masters, his etchings reflect his year spent in Amsterdam on a Netherlands government grant. But this year proved to be as much an affirmation as an inspiration—his prints already had the brooding intensity that characterizes the intaglios of Rembrandt and his circle. His surfaces faintly glow with the striations made by tools other than the usual etching needle—razor blades scraped across the surfaces, raising a granular metal riptide, and other materials pressed into the soft resin layer coating the plate, before its submersion in acid, create a myriad of nonconforming hieroglyphs. It is like watching a wizard perform; no visible effort is noted, but the result is gloriously magical.

In his etching *The Printer* (1970; plate 35), the Rembrantesque figure seems to reach out to us from the shadows with an imploring gesture, a method used by the master himself. Ambiguous space, the deeply bitten blacks, and the use of the white of the paper as another color in his composition characterize many of his etchings. In *Dutchman in Rhodes* (1972; fig. 4), he approaches the subject in a similar vein and we feel we are intimately involved in the portrait as the sitter raises his head, as if he has been disturbed, and gazes at us, not altogether welcomingly. This portrait is flanked by fragments of maps. Breverman would sometimes

Photostat his working drawings and then cut or tear them into design compositions for the backgrounds of his work, a process reminiscent of the bed-bound Matisse's approach to his famous Jazz series.

As with all of Breverman's work, experiencing the prints is vastly rewarding on many levels. Whether working in lithography, silkscreen, or intaglio, he creates tours de force of process, using the medium to accentuate the message of his image, as it was meant to be used. His application of color is subtle, sometimes indiscernible, yet even his black inks are touched with an enriching tone, softening the starkness of a pure blackness.

In 1970 Breverman began making lithographs at Impressions Workshop in Boston, where he continued to work over the next seventeen years. This same year he met fellow artists Hyman Bloom and Fritz Eichenberg, and, the following year, Gabor Peterdi, all known for their own graphic work. Unlike an etching, a lithograph is drawn directly on to a stone and has an immediacy not found in intaglio, on which, in contrast, Breverman often worked the plate for up to a year. The authenticity of his draftsmanship is at the core of all his graphic work, and he is a master of the deft transition between media, subtly folding images and ideas back on themselves. Breverman's facility allows the different works to interact spontaneously, with no self-conscious differentiation between them.

In his lithographic work, such as *Disputation* (1971; fig. 5), the spontaneity of the process of drawing on the stone is reinforced by the image itself, the gesturing figure seemingly caught midsentence. The space is unimportant, though the low horizon line gives a simple context, and we can tell by the stance, the facial expression, and the open-handed appeal that this is a figure in the act of discussing. Similarly, in *Double Beckett* (1985; plate 38), the writer's presence is deeply felt, a larger-than-life figure, multiplied, and seeming to emerge from the confines of the paper's edges. His writing implements and ever-present cigarette go beyond the two-dimensional, reaching beyond the framework of the portraits themselves.

There is an intelligence and astuteness to all of Breverman's work, and his long career attests to his continuing engagement with the world, in all its messiness, joy, and distraction. His art makes us think, connecting us to the past and proffering hope for the future, and cautioning that the two are inextricably intertwined and will always be so.

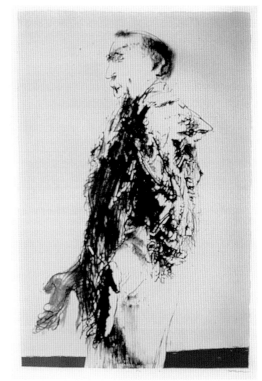

Fig. 5 *Disputation*, 1971, Lithograph, 28 ¾ x 19 Collection of Dr. and Mrs. George R. Levine

Endnotes:
1. Harvey Breverman and Sylvia A. Herskowitz, *Mystery of a Prayer Shawl* (New York: Yeshiva University Museum, 1997).
2. Ibid.

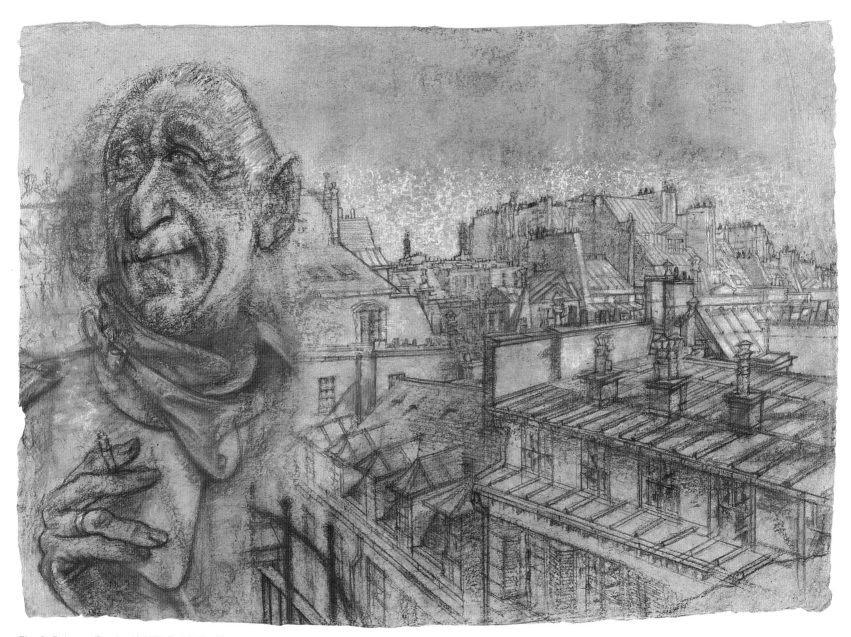

Fig. 6 *Federman (Rue Jacob)*, 2003, Pastel, 23 x 31

BREVERMAN AS IMPRESARIO, BREVERMAN AS JEW
BRUCE JACKSON

Time, Space, and Memory

Whenever I see a great deal of Harvey Breverman's work at one time I recall what is perhaps the most frequently quoted line from the works of William Faulkner. It appears in *Requiem for a Nun*, Faulkner's most historical novel, and it is spoken by the lawyer Gavin Stevens, the character who is perhaps as close to a mouthpiece as Faulkner ever wrote.

"The past is never dead," Gavin Stevens says. "It's not even past."

Likewise all objects that are given form by Harvey Breverman's vibrant and resonant visual imagination. Everything stays in play. Objects and persons imagined and remembered are as present and substantial as objects and persons seen at the moment the crayon touches the paper.

I've read articles in which Breverman is described as an important realist artist. I don't understand this. Real objects and real people populate his works, but the only thing real about the works (unless you count the imagination as real, which those critics do not) is the works themselves—the pieces of paper or canvas so many inches wide and so many inches high. Harvey only pretends to obey the ordinary rules of space, and he never obeys the rules of time and physics that we count on to maintain our balance in life. In Harvey's world, things lurk and hover and impend. A single object or person may inhabit different places and states, and multiple objects and persons may occupy the same space at the same time.

Memory is a major character in Breverman's art, and, like the memory that serves us imperfectly every day, it is never complete or fully reliable. The fact that you can remember something doesn't mean that it happened; it means only that you remember it, which for most of us is one of memory's most troublesome limitations. For Harvey, I suspect that is memory's unending delight and potential. The objects of his memory are constantly reconfiguring themselves rather than bleaching into unintelligibility or nothingness. Images of a page or a room or a cityscape or a face hover, come into the foreground, recede into bare outline, achieve what seems to be full final form, and then reconstitute themselves or recombine with other images and figures in entirely new congeries of the imagination.

It's not that the real isn't here; it surely is. I see in Harvey's drawings and paintings people who have been Harvey's friends, and mine, over the past thirty-five years. Some are not far from where he and I now live. Some have moved on to other places on this earth. Some have died. Memory and art are the last places you die, and the appearance of these people in Harvey's drawings and paintings keep memory alive longer than we who have memories, and in a different way than we who have memories.

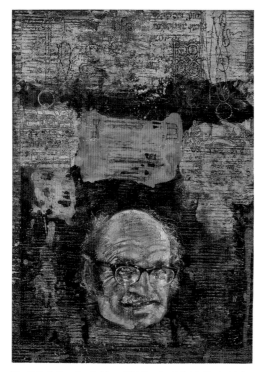

Fig. 7 *Barth: Brevarium Judaicum,* 1999, Pastel and oilstick, 39 ½ x 27 ¾

Memories are everchanging, but art is specific, fixed. Art, like words that have been spoken, can never be undone or taken back; art and words spoken can only be followed.

None of which is to say that Harvey's art is nostalgic. It isn't. Nostalgia is the memory of an incomplete experience, and Harvey's art is about experience that is ever in the present. Completion and incompletion have nothing to do with it. Those bits and pieces of the recent and remote past that he hauls into present consciousness are meaningful not because of what they were then, but because of the space they occupy in his sensibility—and potentially in ours—now.

Words

Harvey can—and will when asked to—explain where everything in every one of his pictures comes from, but I'm not sure in doing that he will be telling you what you need to know. Often you may do as well on your own, which is what I think he expects and wants of you anyway. This is perhaps why he almost never identifies by name any of the characters in his larger works, no matter how famous they are or how loaded with meaning their names are. His drawings and paintings are works of and for the eye.

I asked him, for example, about the figures in his 1992 painting *The Green Book of Aragon II* (plate 6). The primary figure, dominating much of the left side of the image, is a man on a stool, seen in perfect profile. In the center, another man, seen from behind, sits on a different kind of stool, paintbrushes in his left hand. With his right hand he seems to paint on a canvas. To his right and in front of the canvas, a third man sits in a director's chair, looking to the right and out of the frame. In the right foreground a dwarf priest walks toward the center, holding in his left hand a green book.

The book is the only green thing in that entire large painting. The rest of the canvas is drenched in blue. The man with the brushes wears a blue vest and blue shirt. The shirt and trousers of the man to his right and the chair the man sits in are all blue. The dwarf is dressed in a blue-black cassock. The trousers and shirt of the man on the left are blue; his grey hair is highlighted with pale blue. What may be a fuse box in a distant room is blue, as is the floor in that room. The wallpaper of the studio is blue. The shadows on all the skin tones and on the painter's khakis are blue. The polychrome carpet has blue in it. The only objects in the painting that are not entirely or partly blue are the wood of the two stools and the chair, the shoes and sweater of the man on the left, the wall of the distant room—and the green book carried by the dwarf.

"That's Jack Peradotto on the left," I said.

"Yes," Harvey said. "That's Jack." John Peradotto—"Jack" to everyone who knows him—is a classicist on the University at Buffalo faculty. We've all known one another for decades.

I asked Harvey who the man on the right was. He told me. It was someone I didn't know.

"And that's you in the middle, painting and holding the brushes."

"Yes," he said, "that's me."

"But, Harvey, you're painting on the back of the canvas, not the front of it."

"Yes," he said, "I am."

"Why are you painting on the back of the canvas?"

"You're seeing me from behind, so you might as well see the painting from behind."

"Ah," I said. He didn't offer any further explanation, so then I said, "And the dwarf. Who's the dwarf?"

"Him? He's from my imagination."

"And the book he's carrying?"

"That's the Green Book of Aragon. That was the Grand Inquisitor's book that contained the names of the Jews who were to be converted."

Almost. The Green Book of Aragon contained the names of Jews in Aragon who had converted to Christianity. For a reason no one now seems to know, the Aragon Council in 1622 ordered all existing copies of it burned in the plaza of the Zaragoza Market. Only four copies are known to have survived. One of them—or one of the ones that was burned in 1622—is carried by Harvey Breverman's dwarf.

UB's English Department of Legend

If you spend much time around Buffalo you're almost certain to hear tell of the legendary English Department that existed at the University at Buffalo in the late 1960s and early 1970s. Like a lot of legends, there's some truth to those stories—and a good deal of imaginative reconstruction. It's true that Al Cook, who chaired the English Department in those years, assembled a spectacular faculty in a very short time. But it's also true that many of the people who were part of the scene that is imagined so fondly weren't in the English Department at all, and some weren't even faculty members of UB but were, rather, friends or working associates of people who were. Furthermore, the UB English Department of legend took place over time, not all at once. People came and went; some were here briefly, some were here early and some were here late. The UB English Department of legend is more an idea than a fact.

What happened here in the late 1960s and early 1970s wasn't a department, but a dynamic cultural scene and an extended process, and there is only one place it really does exist: in the

work of Harvey Breverman. In Breverman's pictures you find dozens of the people who populated that scene and process: Michel Serres, Olga Bernal, René Girard, and Raymond Federman in French (Federman would later move into the English Department); John Sullivan and Jack Peradotto in classics; Larry Chisholm in American studies; Al Cook, Homer Brown, Robert Creeley, John Barth, Diane Christian, J. M. Coetzee, and Dwight Macdonald in English; Lucas Foss, Alan Sapp, and Jesse Levine in music. And the visitors and friends and colleagues: Robert Duncan, Alain Robbe-Grillet, Michel Foucault, Ruthven Todd, Allen Ginsberg, John Ashbery, Jim Dine, and so many others.

Harvey has favorites among those writers and artists who provided much of the ambience in which he worked and flourished for so many years, and he has his favorites among his images of them. The same image of Michel Serres appears alone, in a group in Buffalo, and in Paris with Michel Foucault and Samuel Beckett. Beckett appears again and again, once facing Breverman, who is wearing a sixteenth-century Venetian commedia dell'arte Zanni mask. Robert Creeley appears frequently in these images, not only in Buffalo, where he lived and worked, but in Harvey's imagination of him in the Nightworks series in *Creeley with Masoretic Notes* (1999). Harvey likewise puts a yarmulke on John Coetzee in *Coetzee in Prague* (1994; plate 19), he makes Allen Ginsberg a panel in *Ginsberg among the Geniza* (1999), and he surrounds John Barth with fragments of manuscripts in *Barth: Brevarium Judaicum* (1999; fig. 7). The Masoretic notes are early first-millennium commentaries to the scholarly Hebrew text; the Geniza are among the earliest texts of the Hebrew Bible;

the Brevarium Judaicum is a fourteenth-century Rosh Hashanah and Yom Kippur prayer book. Harvey's modern writers are painted into another time, space, and language; his masters of words are surrounded by thousand-year-old texts that cannot be read.

Federman

Other than Harvey himself, Raymond Federman is the artist who appears in more contexts than anyone else in Harvey's recent works. Federman made his academic bones writing about Samuel Beckett, another frequent subject of Breverman, but for most of the past forty years he has been writing fiction, most of it about his coming to terms with the loss of his family in the Holocaust. He has been part of Breverman's academic, social, and artistic circle for much of that time.

And, to go by these drawings and paintings, part of his imagination. Federman appears suave in a trench coat in *Interior: Studio Group II* (1991; plate 2) and *Interior: Studio Group III* (1994; plate 3). He hovers like a spirit over the roofs of Paris seen from an attic hotel room in *Federman (Rue Jacob)* (2003; fig. 6). In *Contemplating Paris I* (2003), Federman looks out of the frame to the left and Breverman looks upward and to the right; behind them are faint outlines of Parisian rooftops; in the foreground are three right hands, each holding a pencil. In *Federman: Broken Epitaph* (2000; plate 22), Federman's grinning face hovers under characters from a Hebrew book, with circles, like the end of something cylindrical pressed into the physical surface of the picture. Below the characters and circles is a prosthetic arm, its claw

sitting on the table and its harness going off into unintelligibility to the right. In *Federman: Kol Nidre Elegy* (1999; fig. 8), Federman is on his back, grinning, surrounded by blackness like the grave, wearing a striped shirt that has just enough color in it not to be a concentration camp shirt—but not so much color that you won't think of a concentration camp shirt.

Kol Nidre is the first prayer sung by the cantor on Yom Kippur, the Jewish Day of Atonement. It is a prayer about the annulment of vows and oaths. It is a prayer about connections made, connections broken, and starting over. What is Ray Federman doing on his back, his head and shoulders in black, surmounted by a green frame with ancient Hebrew characters in *Kol Nidre Elegy*? Who is being mourned in that elegy?

The Block I

The answer is perhaps in a later work, the 2002 pastel *The Block I* (plate 26), which has three and a half figures of persons in it and one building. The building might be a factory; it also might be a crematorium in a concentration camp. The lines of the building are clinical and precise; they might have been drawn with a ruler. Blurred smoke rises from and partly obscures rectangular chimneys in the background. Yes, I think it is a crematorium in a concentration camp.

Leslie Fiedler, the late literary critic who was part of the intellectual spine of UB's humanities faculty for forty years, is on the right side of the frame, looking toward but not at the building.

His left hand is raised, moving more deeply into the picture. Federman looks to the right, out of the frame entirely. He is dressed in a striped jacket—perhaps like that of a prisoner.

Both Raymond and Leslie wrote about the Holocaust, but for Leslie it was one subject among many, while it has forever been at the core of Raymond's fictional work.

The third figure is Harvey himself, wearing a turtleneck, as Beckett does in so many of Harvey's drawings of him, and the Venetian Zanni mask with

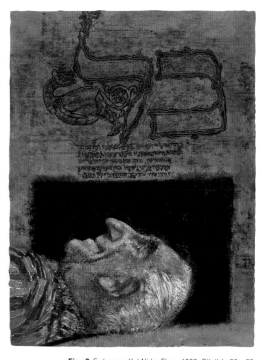

Fig. 8 *Federman: Kol Nidre Elegy*, 1999, Oilstick, 30 x 22

its large hooked nose pushed up atop his head. That mask turns up frequently in his recent work, almost always on his own face or head. In his hand, the figure that is Harvey holds not a sketchbook or canvas but a mirror. Harvey told me that the figure in the mirror is himself, but if that is true it is himself in another time, another place, for the faint, partial figure in the mirror doesn't match the man with the hook-nosed Zanni mask at all.*

So there are three Jews and a Blakean Emanation of one of them, positioned around a building that might very well be the crematorium in a concentration camp. Not one of the

figures—not Harvey, not Leslie, not Raymond—confronts the building or its smoking chimneys directly.

But you and I, who look at the pastel drawing, have no choice but to look at the building with its smoking chimneys directly. You and I: if we look at the painting, we have to look at the building, with its smoking chimneys, directly.

Jew Things

Some of the drawings and paintings are full of barely intelligible or unintelligible but just recognizable Hebrew characters. But Breverman's Jewish symbolism isn't simply the iconography of Jewish things tucked into or around images they have nothing to do with. They carry with them everything, from the mysteries of the Kabbalah to the horrors of the gas chambers and ovens to the pleasures of the family seder. It is no accident that one of his favorite faces is that of Raymond Federman, whose family was vaporized by the Nazis and who has spent his entire adult life coming to terms with the nearly unbearable fact that he alone of all of them is still alive.

All of this becomes explicit in *The D.P.*, a 2002 pastel (plate 25), the title of which is a pun. For any American Jew of Harvey's age, the initials "D.P." denote the refugees from Europe who came to America after World War II, the newly arrived Eastern European Jews who had no home to return to, many of whom arrived here knowing little or no English, the Displaced Persons. In Europe, the initials "D.P." had far greater meaning: all those millions of people of whatever nationality or ethnicity who had been made homeless by the war. But to Harvey "D.P." also has meaning specific to his place in Buffalo: It is his rank in State University of New York. He is a SUNY Distinguished Professor, the highest academic rank in the university system. Harvey is a D.P.

In this picture, he draws himself wearing the striped uniform of a concentration camp prisoner, his face gaunt. Hanging from the prisoner Harvey's neck is the medal the professor Harvey was awarded at the official ceremony promoting him to his present university rank.

There are two disjunctions in the piece occurring about the horizontal line that runs across it two-thirds of the way down. The line is formed by a tear: Harvey started the picture, ripped it in two, drew on each part, then taped them back together again.

Below the line formed by the tear, the stripes of the prisoner's uniform blur and all but disappear; Harvey's D.P. medal rests on that blurred field. And the arm with which the gaunt Harvey draws is detached from the body of the prisoner D.P. above the line. The arm comes not from the shoulder or trunk, but rather straight from the heart.

The camps and the thousands of years of history haunt him; they are ever in his present. *Prague: Tefillin* (2003; plate 28) has his face at lower right, phylacteries on his forehead. Above him, a street in a circle, as in a mirror, and some vague buildings; above all that an arm, straight out, tefillin wrapped as in prayer. And just above it, a large small-windowed factory with a chimney. A factory or a death camp blockhouse? Of course it is a death camp

blockhouse. And *Sacrifice I*, done a year later, has Harvey's face twice, once in rear profile and once straight on, both wearing phalacteries, while to the right an angel halts the sacrifice of a lamb and two figures pray against a field of barely discernible Hebrew characters.

In Harvey's world, all those poets and painters and friends, here and elsewhere, living and dead, can sit in the same room, around the same table, appear in the same mirror, be there while the dwarf of the imagination passes by carrying the Green Book of Aragon. Who knows but that you, too, will one day experience a surprising conversion or see the dwarf walking by, carrying that book or another? The lesson at the heart of Harvey's images is that all remains.

*** A note on Harvey's mirrors:**

Many of Harvey's pictures have mirrors, but they never quite behave as we expect they should. In *The Block I*, the figure with the commedia dell'arte Zanni mask holds a mirror, but it shows an image reversed that isn't quite him. There are three mirrors in *Interior: The Studio VII* (1987), which has Douglas Schultz (then the director of the Albright-Knox Art Gallery) in the director's chair in which Harvey frequently depicts him, and someone else to his left. Mirrors to the left of the man on the left and another to the right of Schultz show the back of each man's head. But both men are looking toward the left, so the mirrors should show the right sides of their faces, not the backs of their heads, and the mirror with the back of Schultz's head is not his head, anyway: It has a different shirt, different hair. The jackets of the man on the left and the man in the mirror aren't quite the same, and neither are their bald spots. Only the center mirror seems to tell us true: It reflects a cylindrical device atop some books in front of Schultz and, beyond that, part of an artist's body, a hand with a brush, the edge of a canvas—the place where Harvey Breverman would be, if only we could see him.

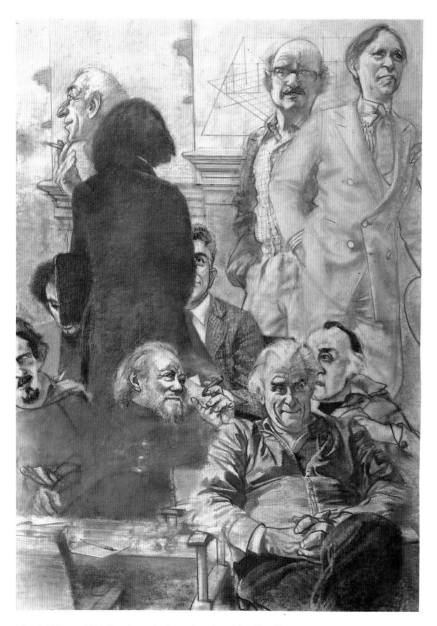

Fig. 9 *Mélange*, 1984, Pastel, conté, charcoal, and graphite, 60 x 42

HARVEY BREVERMAN'S COMPRESSED SYMBOLIC STRUCTURES
ROBERT J. BERTHOLF

As part of the engagement to the art, a poet or a painter creates a fictive or imaginary world to contain poems or paintings. The habitation can be filled with parts of the common world, or parts of the common world transformed by the activities of shaping energies. "That slight transcendence to the dirty sail," Wallace Stevens called the effect of acts of the imagination in his poem "Sailing after Lunch." This process of creating an imaginary world can also involve the simultaneous commentary on what is being created and how. Like the repeated shapes in Miro's Constellation series, images and gestures, which recur and so can be recognized, invent a vocabulary for individual expression. The poet or painter enters the invented world and participates in the details or events of his own making. This might turn to bitter introspection, but it also allows the irony of correction and a chance to change the perspective freely. The paintings and the poems become sequential, then, involved with one another by recurrences rather than rhetorical transitions or casual links. Relationships without a controlling narrative structure invite multiple meanings and the inclusion of all sorts of images and ideas in nonhierarchical positions. Each one of these paintings or poems modifies and enlarges the possible meanings of the other. Paintings in sequence or poems in serial composition permit open, not closed, structures, and provoke an endless conversation.

And so it is we enter the intricate structures of Harvey Breverman's paintings and follow along as he trains his audience to inspect the backs of people in chairs; the activities in an artist's studio; architectural drawings of wooden synagogues in Poland; those coats, with such perfect collars and folds in the arms; and prayer shawls in pairs and alone, silent but carefully drawn to contain the very energy transformation requires. There is not a lot of motion in these paintings, no crashing surf, oaks shattered by lightning, or the rush of city traffic, not even a lobster on a leash. But the paintings have such interesting objects in them to invest the area of the paintings with a rich vocabulary. Take for examples the abstract, geometric drawing on the back wall of *Mélange* (1984; fig. 9) and the spectroscope on the table of *Cabal III* (1987–88), both with figures in a committee meeting. In using the spectroscope, the ore sample goes in the middle of the device, and then attendants look through one of several scopes to determine the spectra of the sample, and so find its identity. The process points inward; it is introspective, just like the committee meeting. It is as if Breverman were taking up one of Henry Fielding's devices and addressing the audience—"Dear happy reader, if you only recognize the figures in the painting as John Barth, Ray Federman, Leslie Fiedler, and others, then you have not read thoroughly, for I have put that object to help you out as the audience." The drawing in *Mélange* describes the discussions of the meetings as abstracted from the particular, perhaps interesting but not applicable. In twenty-five years, the new audience will not recognize Leslie Fiedler, Al Cook, and Michel Serres, but it will recognize the geometric drawing and the spectroscope and the ironic comments they make on the endless introspection of an academic committee meeting. The image of the spectroscope also appears in the painting *Two Jews in Tangier I* (1981).

Other charged objects transform figures. The wooden cap-blocking form appears in the foreground in *Doorway in Jerusalem II and III* (both 1991), for example. A cap maker presses a moist piece of felt down on it, and, when dried, the felt reproduces the shape of the mold completely, realistically. The mold is the emblem of the technique of the painting—realism. The very careful rendering of the folds of clothing, the careful drawing of the backs of figures, or even the sides of the faces and bodies of figures rising from chairs,

exemplify the realism symbolized in the cap-blocking form. A camera and a tripod appear in several of the Interior Studio series, but, oddly, the camera does not seem to be working; and though it could reproduce images of the objects and people, it is not being used for that, but stands with its apparatus as an ineffectual standard of reproduction. It remains inferior to the imaginative action that put it into the painting along with the figures, which are realistic, but not as perfect as the camera could reproduce. The figures are fictive, part of the changing scene of the studio, and they have the energy of the human, not the perfect stability of a photograph. The same figures appear and reappear in several paintings in slightly different poses and with different modifications—the dressed manikin between two cameras in *Interior: Studio Group IV* (1997; plate 4), for example. In *Interior: Studio Group I* (1991; plate 1) one camera is in the middle of the painting, unused, and a stand without a camera, also unused, is at the left, while in *Interior: Studio Group IV*, a photographer is adjusting a modern camera on the right, presumably to shoot a subject sitting in a chair at the middle of the painting. The old bellows camera is on a stand pointing downward; a man on a ladder is looking into the back of the camera, preparing to take a picture, and it is a comical view in comparison with the serious composure of the artist studying a subject sitting in a chair at the left.

In *Interior: The Studio VIII (Doug)* (1991), a construction/sculpture made out of designs for machines by da Vinci appears on the left, while wooden horses, a stool, and other objects above on the right give the appearance of a cubist construction. The complexity of the machines and the cubist views give the sense of the complexity of Doug, the subject, but he is looking at the back of a painting. Something is wrong here; the electric cord around the base of the sculpture of the machines is unplugged. The cord also appears in *Interior: The Drawing Lesson* (1985; fig. 1), and a container for winding up an extension cord appears on the floor in *Interior: Studio Group II* (1991; plate 2). Neither is plugged in. The imagination owns a greater power of transformation.

In *Interior: The Studio VII* (1987; fig. 10) there is another complex figure. This time a sculpture of pistons rests on books (i.e., sculpture based on learning), with a mirror behind (supported by a camera tripod) reflecting the back of the pistons and the artist, who is behind the two seated figures and thus in the foreground, out of the picture, but is reflected into the background of the painting; the artist's head has been cut off by the reflection in the mirror, but in the mirror image he is painting with the right hand. The accent on the arm of the artist (here and in *Interior: Studio Group III* [1994; plate 3]) carries over to the prosthetic arm in other paintings as an emblem of the realistic vision. On the floor at the right and left appear two oil cans, which contain mineral spirits used to mix pigments. The two seated figures are thus framed front and back by images depicting the process of seeing and creating, and on the left and right by the materials of painting. There are brushes in a cup on a stool to the right and a painting on the floor (the back of which is showing) to the left.

Breverman makes symbolic structures to modify the realistic figures. The realistic drawings of the artist's friends and colleagues become part of symbolic structures when the images on the floor and on the back walls inject speculation about the acts of seeing and knowing into the changing contextual design. The fictive symbols modify the realistic images. Breverman's strategies become more intricate and refined in the Nightworks series, all of which are made on black paper, with pastels and oilstick, but some of the surfaces have been made with pastels mixed with mineral spirits rubbed on the surface, effaced, built up, and some with finger strikes of oilstick.

In the Nightworks series Breverman proposes an idea of artistic traditions supported by Jewish literary and religious traditions. The works are not portraits of the people named, such as Beckett, Coetzee, and Fiedler, but a presentation of the writers (writers, mostly, and one painter) surrounded by images of language, decorations of illuminated letters with animals, imaginary small dragons and creatures from medieval apocalyptic literature,

various decorated borders and a fine-tuned sense of colors—all of which support a profile of the person, not a biography, but a version of the writers in images, in a compressed symbolic structure. Most of the figures are smiling. *Beckett in Prague* (1994), for example, has ornate decorations on the right and top, with imaginary animals and birds around the head of Beckett, and then a shelflike medallion at the left with Hebrew letters presented as images. But among them is Aleph, the first letter of the Hebrew alphabet, the beginning and the origin of language, the preeminent letter with great power in the orders of the Zohar. The emblems of the imaginative life are on the right, but the left of the painting is open, an open-ended structure, the freedom of the creative mind modified but not contained. The same design works in *Coetzee in Prague* (1994; plate 19), with decorative borders with emblems of flowers at the right and top. The orange of the border appears also in the eyes of the figure, and even with the smile the terror of the eyes and the head in the brownish background sketched with language gives an ominous image.

There are three pictures of Leslie Fiedler. *Fiedler in Moravia* (1994; plate 20) shows his head facing left (as his political views always did) with a radiant crown of fabric—a Torah cover studded with precious jewels, which sign the Jewish six-pointed star. The second has Fiedler again facing left, but this time his head is surrounded with architectural drawings, imaginative structures of the mind, which move upward. These are actual floor plans and drawings of Polish synagogues that were burned in World War II, but the symbolic views of the mind's creative activity imbedded in ancient structure of the Jewish traditions come through. The third Fiedler piece has the head again facing left with the fabric crown above, but now surrounded by a field of the gold of perfection, wisdom, and divine intelligence, protected on each side by a border of green designs. Above the crown and the illuminated letters from medieval manuscripts appears, for the first time, a prosthetic arm, and then above it an image of a wooden synagogue, now destroyed. The arm is a complex image related to the realism of the scenes in the studies,

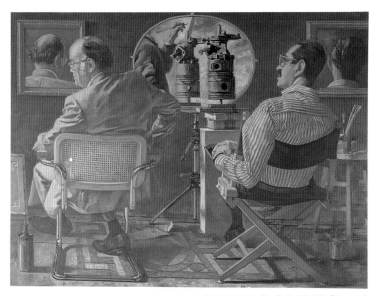

but also an emblem of Nazi suppression and cruelty, in that Jewish prisoners were forced to shed false teeth, glasses, and all prosthetic limbs. It appears in *Poyln: Sokolski* (2000) in a coffin in front of a wooden synagogue, which is lighted from within.

The arm also appears in *Federman: Broken Epitaph* (2000; plate 22) at the bottom of the painting, and above it there is a black, smudged area with the emblems of Zyklon B canisters (two circles connected by lines) on either side. A smirking Federman looks over this emptied scene, with Hebrew letters made from animals as an image above him, with the same multiple meanings, the realistic image in a field of muted and unfulfilled designs. *Federman in a Gilet* (1995) continues this same kind of construction, with Aleph at the top of the page, and then texts in Hebrew running down behind the smiling head. The gilet (a vest) is decorated and appears regal. On the left and right, strokes of red move from the margins to the image of the text, the strikes of brilliant creativity supported by the Jewish traditions in Federman's writing.

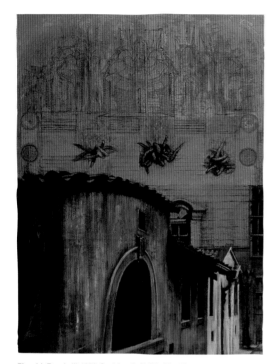

Fig. 11 *Terezín III*, 1993, Pastel and oilstick, 60 x 44

The same kind of effect appears with the striking, passionate red in *Levi: Lamentation* (2000; plate 23) or the striking block of the orange of ambition in *Barth: Brevarium Judacium* (1999; fig. 7). The next, *Ginsberg among the Geniza* (1999) has the Aleph in the style of an illuminated manuscript at the top, the subsequent text and more illuminated letters as demons on the right and left, supporting the connection between the poet and the traditions with the color of the letters in red matching the red of the poet's tie. *Creeley with Masoretic Notes* (1999) is cooler, in blues of contemplation and greens of the earth's fertility, sympathy, and adaptability and some yellow of intellect and intuition, but the decorative borders are on the top and left and the abstract geometric designs move from left to right up out of the open side of the painting. The message here is the same: The poet is sustained by traditions and surrounded by his imaginative designs, his symbolic structures. *Duncan: The Schwa Vowels* (1999; plate 21) is also cool in blue and purples, colors of religious feeling, contemplation and devotion, and memories (Duncan's references to "Mnemosyne," the mother of the Muses in his serial form *The Passages Poems*), and some green and yellow, Apollo's color of intuition and intelligence. Duncan is surrounded by his own drawings of imaginative animals imbedded within the structure, and again the Aleph, which he read about in the Zohar, and another emblem of a hand containing Hebrew letters, but principally Aleph, which also appears on the left in blue. The figure is surrounded by the primacy and generative power of language.

Poyln: Sanok (2000) typifies another section of the Nightworks series, without human heads; the painting generates a complex symbolic structure that moves from bottom to top. At the bottom right is the image of an actual building (Krakow's Wysoka Synagogue), and then above it is a line drawing, a floor plan of another synagogue in the shape of a chair with a decorative Polish eagle (wearing a crown) just above it, and above and around it are a collection of images over a map, all moving upward. The same hand that appeared in the Robert Duncan painting with Hebrew letters (including Aleph) on its nail appears at the left side, giving directions. At the top a small fire burns. *Terezín I* (1993) follows this structure with an actual building on the right, then moving up on the left fire appears, and then flaming stacks and more fires, with the yellow star marking a Jew in Nazi Germany in the middle. *Terezín II* (1993) pictures a building with a clock (on which Aleph equals 1) marking it in the physical temporal world, then two blocks of golden fires in the middle, and another set of drawings of a destroyed synagogue at the top; the golden design has the appearance of an apotheosis of the actual building into an ascending imaginative building. "Visible transformations," Wallace Stevens called such perceptions in "Reality Is an Activity of the Most August Imagination."

The same three art structures and artistic processes appear in *Wimpel: Galicia* (1995). The movement in these paintings enacts the imaginative process of transforming the actual images into an imaginative structure. *Terezín III* (1993; fig. 11) joins this group with a circular building at the left, then three emblems of barbed wire in the middle against a golden wall with partially drawn figures in blue at the top, giving a spiritual ambiguity of intention here—the transformation has been incomplete, and is not as precisely known as the transformed image of the synagogue in *Terezín II*. The same incompletion appears in *Terezín IV* (1993), with red and burning at the bottom, then a line of barbed wire, here an emblem of imprisonment and cruelty, with buildings in red and an incomplete drawing of buildings at the top. In the final painting, *Poyln: Grodno* (2000; fig. 12), the passionate

energy of red covers all, but here it takes on the meaning of wild, destructive forces as the broken prosthetic arm appears in the foreground and, above it, train tracks, emblems of deportation that lead into the gates of Auschwitz, and behind the gates a large image of a synagogue, burning, dominates the painting. The buildings may have been destroyed, but their place as imaginative structures remains, fortified by Jewish texts and traditions.

Some of the same images appear and reappear in the Nightworks series paintings devoted to writers, and in a subsection of that series, these paintings of buildings, develops another set of defining images, all announcing the processes of transformation. In the three-part structure worked there, Breverman demonstrates a creative process in a movement upward, even when the images of human degradation and physical destruction have destroyed buildings, killed people, and slaughtered traditions. In these paintings, Aleph generates new beginnings and so symbolizes the creative will; still, other structures of meaning become possible. As Breverman shows in *The Block I* (2002; plate 26), which features images of Leslie Fiedler, Ray Federman, and the artist (wearing the Venetian mask from the Studio Group series and from *Beckett in Venice* [1984; plate 11]), and in the set *Nights in Warsaw* (2003; plate 27), he shifts his procedures to drawing and exemplifies the processes of his art. The kinship with Irving Petlin and R. B. Kitaj is provocative at this point, in the colors and the drawing of human figures in an urban scene. In the new series *Contemplating Sarajevo* (2003; plates 29 & 30), which features portraits of Endi Poskovic—a former student and now an internationally known printmaker—Breverman creates images of the city of Sarajevo behind the portrait, and leaves in the false start and even mistakes of his drawing in the same way that Robert Duncan retains miswritten lines in his poem "The Torn Cloth." And by placing images of his drawing equipment at the bottom and sides of the drawing, he demonstrates that enacting the process of the drawing is as much a part of the picture as the central images. Robert Duncan, Bob and Penny Creeley,

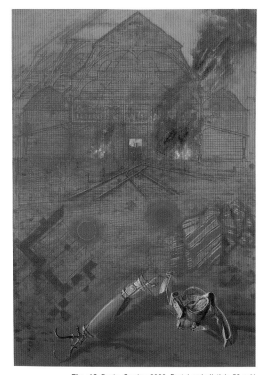

Fig. 12 *Poyln: Grodno*, 2000, Pastel and oilstick, 59 x 41

Diane Christian, and Bruce Jackson, as well as Jim Dine—who had appeared earlier in the Nightworks series wearing an elegant bronze crown—and Ray Federman appear in the unnamed series of drawings now more focused on the images of people and less on the religious and literary traditions (though that is not true of the painting *Duncan: Opening the Field* [2003]). When the subject of the paintings becomes the process of conceiving the spatial relations of figures and images, then the seriality of the works presents versions of the things seen and transformed. Endi Poskovic's portrait can appear many times in various stages of composition foregrounding a cityscape of Sarajevo; Ray Federman and Leslie Fiedler, and the artist also, without a mask, enter because the point of the paintings is a demonstration of the process of transformation, not the details of a realistic portrait.

The process of transformation replaces the spectroscope, the unplugged cord, and the camera and its stand in these recent drawings. In the later poetry of Wallace Stevens, poetry became the subject of the poem with the process relinquishing any "vivid transparence" of the scenes described, and in the recent work of Harvey Breverman, elucidating the process of transformations in symbolic structures in which the author also participates take preeminence in versions that fulfill the possibilities of open, serial forms.

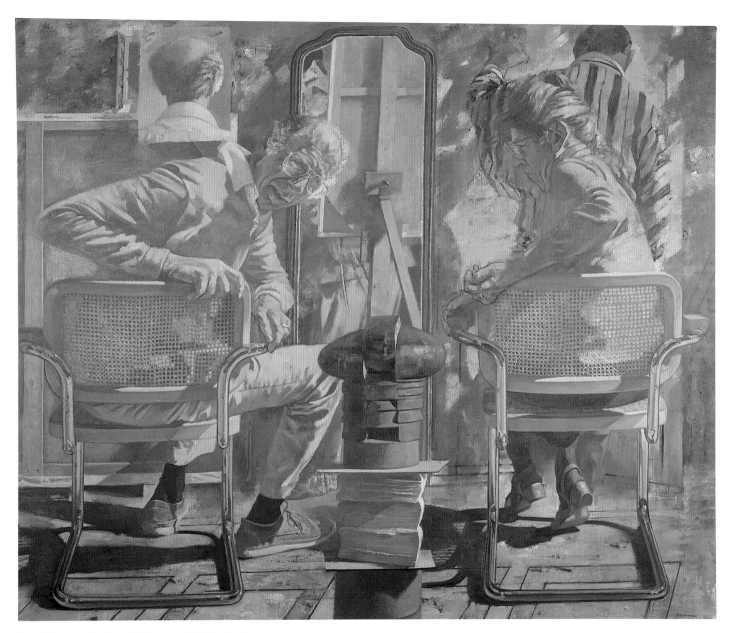

Fig. 13 *Interior: The Studio VI (Homage)*, 1987, Oil, 60 x 72

CONVERSATION
SANDRA FIRMIN AND HARVEY BREVERMAN, JUNE 2004

SF: You attended Carnegie Mellon University, then Carnegie Institute of Technology (CIT), from 1952 to 1956, a time period which represents a pivotal moment in the history of modern art, when iconic European artists were still alive and working, yet there was a pull toward a younger generation in New York, first with abstract expressionism and later pop art.

HB: Still alive and active, Matisse, Braque, and Picasso were the reigning giants. Their pictorial innovations filtered into the classrooms, as did the lessons of Cézanne's landscapes and still lifes.

The contemporary gallery scene in New York was modest. Jasper Johns, Robert Rauschenburg, and George Segal had not yet had solo shows. British pop art—and Californian, for that matter—did not explode until the early 1960s in the guise of R. B. Kitaj, Richard Hamilton, Eduardo Paolozzi, Patrick Caulfield, Joe Tilson. Enamored with the photographic image and American consumer icons and goods, Hamilton had, by 1958, ventured into this wide arena. Their attempts to wed figuration with abstraction intrigued me. Andy Warhol and Philip Pearlstein had graduated from CIT a few years earlier and were mentored by the same teachers as me.

With military service in Korea completed in 1958, I enrolled in an MFA program at Ohio University. Willem de Kooning and Arshile Gorky were known to me. De Kooning's early work informed my forays into figure-ground relationships both in painting and drawing. But in the early 1960s, I embarked on figurative narratives triggered by my take on events and the world. It seemed then that it was possible to forge an art that depicted real things with underlying abstract principles.

SF: There are many notable connections between your work and life and that of Kitaj. Not only did you both embrace a European figurative

tradition in opposition to the dominant abstract expressionist mode of the 1940s and 1950s, but you were, coincidentally, born two years apart in steel mill towns, you in Pittsburgh and Kitaj in Cleveland.

HB: I grew up in Pittsburgh's Hill District, which was an ethnically diverse community, rich in spirituality, but materially poor. Our three-room upstairs flat bordered a narrow concrete alleyway next to Passavant Hospital. It was a life on the streets—people integrated with one another, lived close together, on top of each other. The human charade was a central and perennial unfolding drama of experience. I have no recollection of grass or color, only concrete and life lived in black and white.

After I moved to Buffalo in 1961, my work shifted from semiabstract figures, singly or in groups, fractured by light and figure-ground ambiguities, but executed in a vigorous abstract expressionist manner. Gradually, I attempted to operate in that gap between art and life and reflect on my own set of experiences, both secular and religious. The challenge became my raison d' être. I knew that painting figuratively put me at odds with prevailing taste, but we were on the cusp of pop art. Artists like Kitaj appealed to me, as did Hamilton, because both were grappling with the inclusion of the figure in odd, contemporary contexts that simultaneously embraced a larger European continuum.

SF: In the mid-1960s you went to Holland as painter-in-residence at the Royal Academy of Fine Arts in Amsterdam. This experience must have made a profound impression on you and your work.

HB: My artistic and psychological mindset was in Amsterdam before I arrived. I had been fascinated with Rembrandt's humanistic vision realized through personal intensity and luminous painting methods. Likewise,

I responded to Frans Hals's *ala prima* brushwork and, like Rembrandt, an uncanny skill in weaving together many figures into large, corporate pictures. The magic and brilliance of Gerard TerBorch also captivated me. Though I discovered Vermeer in Holland, I was far less interested in the intimate genres painters.

While I purposefully lived a hermetic life in the studio, I was equally immersed in the material evidence of Amsterdam—rich collections in public and provincial museums; historical collections and archives; seventeenth-century architecture not yet modified by affluence; churches, old synagogues, secret Calvinist prayer halls, cafés, and public markets. I walked and sketched everywhere.

As I worked with people that the academy brought me off the street, instead of models, my paint handling became more articulated. I worked wet into wet with pigments thick and thin, juxtaposing colors to achieve luminosity rather than through layers of glazing. I committed my first impressions and sensations directly to canvas. A range of grays mixed with complements broadened the palette and I shifted to the use of blues, yellows, and ochre.

With aerosol cans not yet in existence and fixative difficult to find, I eschewed charcoal and conté in favor of vigorous ink wash drawings executed with reed pens, quills, sticks, and brushes. The use of these materials was likely triggered by visits to study Rembrandt drawings at the Rijksprentenkabinet.

I often traveled outside Holland to Spain, France, Belgium, England, and Switzerland and developed a habit of drawing obsessively in trains and buses, cafés and concerts, to capture a fleeting moment, a glance, a gesture, an architectural detail. As for stories I heard, these I filtered through my imagination into pictures about places I had not visited. Travel continues to be stimulating as I retain impressions and associations with historic districts, memorable avenues, and rooftops.

SF: In your early prints the figure appears completely anonymous as opposed to the later works where you represent explicit people. Could you talk about this shift in your work?

HB: The anonymous figure is in fact me. I depicted myself as an archetypal gestalt shrouded in strange, exotic ceremonial garb. The figures are Everyman. After my return from Amsterdam, figures grew to life size as they became more painterly. Suddenly, it seemed natural that the company of writers, poets, musicians that I sketched and drew as I entered their world, and they mine, was introduced into my artworks, especially the etchings and lithographs. I came to admire these figures who, like me, struggled with artistic creations.

SF: Your compositions situate the figure in curious surrounds where the objects and architecture, both peculiar and everyday, seem off-kilter. Kitaj said that he was engaged in an American-style surreal symbolism.[1] Could this term be applied to your work over the last twenty-five years, and how would you define it?

HB: The surreal has much to do with literature and psychoanalysis, a world of dreams, invention, and odd juxtapositions. The latter engages me the most. My painted and drawn situations do not play out logically. Circumstances they seem to depict are puzzled together from a mix of studio paraphernalia and clutter, architectural fragments and ordinary, legible objects. These recombine and collide in shallow, constricted space suggesting ambiguity, contradiction, irrationality, and, of course, multiple interpretations.

SF: Your figures are almost always drawn from life and then reconfigured into quirky and, at times, impossible situations. This is evident in *Interior: The Studio VII* (1987; fig. 10), in which you depict how we might imagine ourselves being seen by others. It reminds me in particular of strategies René Magritte employed to talk about the artifice of painting.

HB: Of course, I am not grappling with surrealist motifs, as Magritte would have done, by magnifying forms. In the painting you mention, I created a strange episode in the center where the mirror mirrors what happens outside the actual painting. I've included three worlds, in other words, a triangulation: the world in the painting, the world on the wall with the depiction of two people from the back seated in three-quarters profile, and there is the viewer's world alluded to by the elliptical mirror. The so-called sculptural unit in the center, a double auto piston one on top of the other, sits on a base surmounted by law books. There is an overload of sensory stimuli. On-site sketches in the Albright-Knox's sculpture court provide the floor pattern.

SF: What role do mirrors play in your work?

HB: The mirror achieves several effects: the reflected depiction embraces a reversed segment of the world outside the painting as it extends illusionistic depth through the wall and beyond; the depiction in the mirror may in fact appear to be a framed painting; the viewer might be seduced into self-reflection thereby gaining private entry into the work. My own flopped mirrored image in the act of painting assigns to me the role of narrator.

SF: You present objects as artifacts or clues requiring an investigative mindset by the viewer.

HB: The mere accretion of stuff I put in a work requires some detective work and analysis—brass solvent cans, photographic equipment, art-making instruments (the tools of the trade), an extension cord here, the back of a stretched canvas there, the cap-blocking form, and, of course, the chair.

The deck chair, for example, with crisscross bars at the bottom—the way one sits and slouches in that thing, has trouble turning in it, is enveloped by it—serves as an enduring motif.

SF: Many people would not recognize the cap-blocking form. How do you interpret such an object in which you understand its meaning and function, but other people might see it as unusual, maybe even as an artistic invention?

HB: By including this manufactured object in my work, I've given it aesthetic, iconic status. As a complex form its sections come apart and can be reassembled. In *Interior: The Studio VI (Homage)* (1987; fig. 13) it is the finial on top of stacked phone books forming the vertical foreground anchor of a spatial quadrant.

In *Doorway in Jerusalem II* and *III* (both 1991) it is an object of contemplation and veneration in dialogue with a single figure. The cap-blocking form sits in the studio, raises its voice from time to time and asks to be used like a chair or doorway.

SF: How do you want religious objects to resonate for people who may not be familiar with their ritual meanings?

HB: Individual perceptions and interpretations on my work vary accordingly—as it should be. Ceremonial vestments, adornments, and ritual objects in houses of worship and in the home are part and parcel of organized and private religious practice.

A portion of my work, and specific series of works, attempt to wed the secular with the religious, the mundane with the spiritual, and to evoke, through my own experiences and ruminations, common threads that touch upon the universal, the invisible, the magical, and the mysterious. In the pastel, *Prague: Tefillin* (2003; plate 28), the phylacteries' two parts, the binding on the left arm and a separate unit placed over the forehead, become bit players in an oddly contextualized format.

SF: Your work often deals with objects (chairs, the cap-block) and clothing (empty jackets, prayer shawls) that carry the trace of the absent human form.

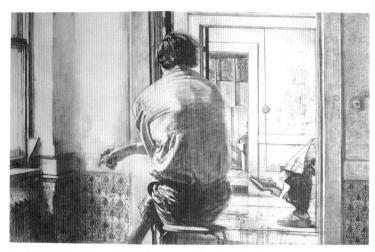

Fig. 14 *Interior: Four Rooms*, 1982, Pastel, sanguine conté, and wash, 48 x 76

HB: The chair is a vessel in which someone is enveloped. It's a receptacle for the activity of sitting as distinct from standing. I often map from the back how a person comports oneself and how, as they relax, begin to change character. If I'm in line behind other people, I inspect the confluence of collar, neck, and hair. Chairs and stools are part of studio paraphernalia as well. They're like people. I am curious about how chairs are stacked, how provisions are made for the stacking process.

They also suggest the body in a personalized way. When one sits in a chair at a meeting, it accentuates a posture. As I sit upright and look at you I may be affecting a certain demeanor that if I were alone waiting for you would be different. When I'm drawing, people become more like themselves as I glance back and forth and document the accumulation of glances. That is the fascinating nature of this unfolding scenario as my so-called models sit and slouch and not only feel comfortable, but may become more uncomfortable.

SF: You often depict the same person multiple times in slightly different poses or locations in the same room. This presentation seems to rely not only on the body's memory of its circumnavigation, but suggests different facets of the same personality. Does this compositional strategy, by evoking movement, relate to the futurists' preoccupation with motion and rendered time?

HB: By knowing about futurist and cubist innovations, an artist has to employ some of those strategies in order to imply movement on a fixed surface. The multiple views of a figure suggest the passage of time and memory. The minute we change even an inch or two, or shift in another direction, we reveal components of ourselves that are altogether different.

SF: Your paintings are practically life size. When looking at your work, I often sense that a person can walk out of one painting into another. Ideally, how do you want people to interact with your work?

HB: I prefer to have the work hung low so that one can walk into the represented space after prolonged looking or, perhaps, in an off moment, to just say, "I can enter that world." Or equally, that that world may enter ours. There's a mix between the space we inhabit outside the picture, the actual viewing and apprehension of the work, and the work itself. And that's why several works tend to be stereoscopic, almost like a Cirkut camera that scans an area, giving you a wider view than could be accommodated in one looking. You have to slide back and forth and in that process begin to enter the time of the painting.

SF: The narrative time in your works is jumbled rather than linear. For instance, you have placed a standing Raymond Federman in the exact same posture in two different paintings, even though in one work he is in the center and at the left edge in another. It is as if he is in two paintings simultaneously or walked from one to the other.

HB: It's a bit of theatre. To some extent I am a stage director, orchestrating where those figures will be from a set of tracings made from smaller drawings that I then enlarge, coating the back with graphite or conté. I cut

them apart, move them around, and pin them to the flat surface to see how things intersect or disconnect; how a viewer gets from one figure to another. The shallow space the figures inhabit creates a degree of tension. Objects and gestures at the periphery become important. Someone leaving the stage, having uttered a word or two, or in complete silence, then reappears partially: a leg coming forward, a partly revealed arm reaching from behind a curtain and overlapped by another person.

SF: How do you decide on your groupings of people?

HB: The oversized pastel *Mélange* (1984; fig. 9) brings together poets, writers, and linguists. My backlog of drawings and notations of each person was a key ingredient and I had them articulating—as they did so beautifully—becoming performers in my drawings and paintings. In their individual ways they're all flamboyant. Each one has a Buffalo connection. Olga Bernal, an always-regal retired UB French professor, appears as the one woman in the work—from the back wearing black—serving as a foil around whom fragments of other notables partially reveal themselves. Michel Serres presides in front—he had just been elected a member of the prestigious Academie Français. And there is Leslie Fiedler, Robert Duncan, a younger Robert Creeley, René Girard, John Barth, and Tom Wolfe. I needed a counterbalance on the left. I called Raymond Federman's home and was told he was playing golf but would be sent over immediately. So I was suddenly able to get Ray in and his persistent smoking enlivened the hand-face connection.

SF: In your paintings the figures are solidly fleshed out. Are there characteristics about the drawing materials you use—pastels, conté, charcoal, or graphite—that allow you to convey movement? There is a ghostly aspect to these works as bodies appear to retreat or dissolve. Could you also talk about the differences between painting and drawing the human figure?

HB: Drawing has a lot to do with the ephemeral quality of chalks and pastels and how they respond to a variety of paper types, whether rough or smooth, handmade or machine manufactured. There tends to be a flexibility and fluidity, like life itself, in that they can be easily manipulated. Simply, with a light swipe of the hand, an entire expression is gone. One can, for instance, quickly erase or reposition an arm. In painting it would have to be done with rags and spatulas to remove the physicality of pigment. In drawing, the media are so effervescent, that is, can be blown away with heavy breathing, a flick of the finger. The hand will alter charcoal, chalk, because it relies not on being part of the grain of the paper, but floating on the texture of the paper. Subtle nuances occur that may alter the drawing and suggest multiple movements and expressions and those gestures happen rapidly. There is a lot of intuition and body language in the act of drawing. A feather dragged across the surface will create a special effect. I can take a paper towel that has been softened and hit the drawing. I can even sand away an area. It leaves a palimpsest, that trace of its former self. I use mostly handmade, deckled-edged paper. The black paper in the Nightworks series causes luminosity that occurs almost immediately.

SF: You've mentioned in previous interviews your filmic concerns. Are you influenced by cinema? I am especially thinking about the way the camera manipulates space by attenuation or compression.

HB: Focus and out-of-focus, transparency and translucency interest me. There is compelling visual excitement and significant visual breakthroughs in film. Serge Eisenstein prepared elaborate notes for *The Battleship Potemkin* (1925). Then, in the cutting room, in the reassembling of filmstrips, new energy and meanings emerged from the inventiveness of improvisation. Most of the Interior/Exterior series are horizontal format, echoing the shape of a screen. At times parts of my pictures appear spliced together, causing separate events to conjoin.

SF: The way you map out space is related to film. In the Interior/Exterior series you present dramatically compressed panoramas, but in some of

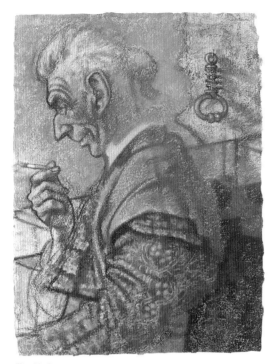

Fig. 15 *Beckett as a Matador*, 1984, Pastel, 31 x 23 ½

the other works the space penetrates the painting by multiple rooms receding back, one after the other. There is also anxiety and claustrophobia in your paintings because of the people, clutter, and contained spaces. These are strategies directors will use cinematography to accomplish.

HB: Claustrophobic is the perfect word. There is a sense of unease when looking at some of the pictures because they are so crammed with stuff. Over the last twenty years the space has become more compressed and the activity takes place in tiny areas. In *Interior: Four Rooms* (1982; fig. 14) there is a sense of deep space and ambiguity as to where rooms begin and end, in which rooms the figures are sitting, and yet a urinal in the back marks its terminus. It is a complicated work, seemingly simple, with a lot of perpendiculars, many of them less than 90 degrees.

SF: Your paintings are filled with people in tight quarters, but there is little interaction between them. They ignore each other. I feel like your paintings are very audible, full of shuffling and sighs, but these people are incapable of speaking to each other. Your work is philosophically ambitious because it tries to convey thought.

HB: In a Beckettian way, many of them are situated between hope and despair. Their lives unravel, at least in the life of the painting, in a private manner. They don't engage the glance of others. People sit alone in

rooms. I watch people in restaurants and in meetings, and while they're engaged, their minds are elsewhere. Life's panoply of activity is not unlike what happens in my pictures.

SF: You have an entire series based on Beckett, and other than Primo Levi, he is the only subject you did not draw from life, but used secondary sources.

HB: The series came about because at Ray Federman's urging I wrote to Beckett. They saw each other regularly when Ray was in Paris. Ray was his first serious biographer and he supplied me with fascinating photos that his son took. What flowed from those initial photographs is Beckett as a wispy, half-disappearing magical apparition.

In *Beckett as a Matador* (1984; fig. 15) I was struggling to resolve the matter of the tied hairpiece behind Beckett's head and how to draw a convincingly decorative vest and sleeves. The idea for the drawing grew from an object I had been given—a device that is attached to a bull's testicles to make the bull jump. For years, that object hung from a nail in my studio.

At my wife's urging, I left the studio momentarily to watch a TV movie about Spain and bullfighting starring Ava Gardner and Robert Stack. I made the necessary sketches on the spot and returned to the studio and put the vest and hair knot in place. Since I had been using myself as a model from a mirror, I included my off-yellow L.L. Bean shirt collar with a brown sweater torn off just below the shoulder.

SF: It seems out of character because bullfighting is as exciting as you can get, and then you have Beckett.

HB: There is a purposeful boredom in Beckett and one has to stick with him over the long haul, over the repetitious pauses, spaces, and silences. Bullfighting is a repelling activity, dealing with life and death.

SF: Could you talk about your interest in self-portraiture?

HB: It tracks a life. It tracks the aging process. One of the most powerful genres that Rembrandt opted to use was self-portraiture, and it has a rich contemporary history. For me, self-portraits engage issues of identity, disguise, and deception. They are constructs on artistic and social reinvention. Posture and clothing are essential ingredients.

SF: Many of your self-portraits are humorous.

HB: I do not smoke, but I appear as *The Dandy* in two different pastel drawings from 1980 and 1986 as if I am smoking. I bought a pack of cigarettes for the purpose of seeing how I might hold one. Curiously, I was invited to a magnificent formal dinner for Semyon Bychkov, who was leaving the Buffalo Philharmonic to conduct the Paris Symphony Orchestra. Given the small, distinguished group, it's likely I was the only one who had to rent a tux. The tuxedo neutralizes the personality, and that is why I find formal wear funny. Everybody looks good and elevated to a higher status. I had the tuxedo through the weekend so I went into the studio Sunday morning and drew a version of the second Dandy. Below the jacket I wore cut-off shorts. I am sure I got my money's worth!

SF: Your work deals with the predicament of human existence, how we can never truly understand each other, but at the same time there is much joie de vivre. You are willing to laugh at yourself in ridiculous situations.

HB: I try not to embarrass others, but I certainly can, and do, poke fun at myself. It serves a counterbalance to the gravitas of my other artistic expression.

SF: Could you talk about the relationship between painting and prayer?

HB: The act of painting and the act of praying both involve enormous commitment, obsessiveness, and an understanding of what one is doing while contrarily believing in possibilities, which is what making pictures is all about. Painting with a skullcap elevates me to another realm in the act of working, and if I am depicting tefillin wrapped around my arm it both continues the ritual of praying and moves it into a secular context.

SF: In the exhibition and catalog the Empty Jacket and Mystery of a Prayer Shawl series (plates 14–18) are put into dialogue focusing on a consistent theme in many of your works, which is the interplay of secular and religious imagery.

HB: They are stand-ins for human presence. The act of painting and drawing might be my way of performing the required number of prayers on a given day. The early prayer shawls include the back of a head. I got rid of it after three or four works because I wanted to focus more on the floating prayer shawl without any evidence of the human figure. I found the enfolding of these garments, which really are all-enveloping, literally wrapping oneself in religion, the twists and turns of wool, and complex striping, startling.

SF: Your delight in depicting fabric is evident. Do you see a correspondence between cloth material and the range of media you use?

HB: My excitement with the complexity of folds and how they suggest what is going on underneath is probably why the nude has not surfaced in my work. There is something affective and mysterious about a body partially clothed, a blouse half unbuttoned, a tattoo on an arm. Body parts revealed here and there is seductive. A zipper. A turned up collar twisted one way. A suede jacket. A corduroy jacket. A windbreaker. Someone brought me a denim jacket and I rejected it outright because it was something I wouldn't wear. The prayer shawl is very much my identity. The shawl falls in the act of praying and swaying, it slips down, the fringes drag along the floor and one has to pull one or both sides up again. With a flick of the hand and fingers, the prayer shawl is once more draped over the shoulders, assuming a new configuration.

SF: The surfaces of your work are highly textured, especially in the Nightworks series. There is a tension between the violent handling of

materials and paper that corresponds to the darker imagery, which includes references to the Holocaust.

HB: The vehicle that activated the Nightworks (1989–2003; plates 19–30) was threefold. As a longtime student of Holocaust history and, though not a survivor, one who lost relatives in Eastern Europe, I grew up in that dark time in the United States with all of its requisite baggage.

I considered the following: Was it possible to convincingly visualize and concretize what was for me, and others, the twentieth century's most systematically orchestrated episodes of mass genocide? Could I deal with the issues tangentially instead of head-on? I wanted to scrupulously avoid emaciated corpses and Nazi heraldry.

Second, the artistic structures that propelled the series came via the richly documented history of destroyed wooden synagogues in Poland, Lithuania, Belorussia, and the Ukraine. Elevations and their complex structural properties, as well as the richly embellished interiors, became the basis for my pictorial exploration. I pondered these thoughts at the onset of being sequestered for three weeks in a large studio atop Mount San Angelo in Virginia.

The first Gulf War also influenced the Nightworks. The burning oil wells put on fire by retreating Iraqi troops reminded me of the smokestacks. When the Jews were interred, they could smell flesh coming out of the chimneys. Guards and kapos would point, indicating, "You will go up the chimney. That will be your end." In this instance, Himmelweg was our alternative path to heaven.

As a formal language, the Nightworks utilize montage, composites, fragmented images, complex spatial configurations, and heavily layered and effaced surfaces. These elements developed from both improvisation and careful analysis.

The effort was served by large sheets of heavy black rag paper. The surfaces, resistant to abrasion and constant reworking, were capable of holding and cementing layers of oilstick, livestock marker pigments, pastel and conté. The vertical format measured sixty by forty-four inches. For the moment, the inclusion of poets and writers left center stage, soon to return with a special fury and commanding presence—done on the same paper with an expanded visual vocabulary and inventory of images.

SF: You render architectural diagrams of wooden synagogues precisely with clean incisions, yet the allover surfaces are typically expressionistic.

HB: You are making a connection between incisions and medical experiments conducted during the Holocaust. I asked for some barbed wire when I was in residency in Virginia to look at how the knots are configured. I was in an enclosure surrounded by a working farm demarcated by barbed wire and could see cows outside my studio. I even went so far as to pick up cow dung. Because it provided the color and substance I needed, it appeared on the surface of my artwork. At night, I walked along the perimeter dotted with spotlights. It could have been Auschwitz. And I thought: I am living someone else's life. I am living someone else's stories.

SF: These works seem much more introspective. You are going to books as source materials, a retreat into history, rather than drawing from life. There are still fragments that viewers are asked to decipher, but space is represented differently. Even the title of this series implies something cosmic or mysterious.

HB: I am trying to make twenty-first-century illuminated manuscripts. They focus largely on a mélange of materials, the linking of fragmentary forms and elements, combining ancient architectural floor plans and elevations, Hispano-Iberian illuminated manuscripts, Masoretic texts, marginalia, folkloric symbols, and ceremonial artifacts. I take fragments from several worlds, allowing them to collide, intersect, and be superimposed.

Each work has a different color scheme and notional system that gives off an emotive and psychological effect. In *S.P. as a Berber* (1999), the oranges and yellows convey heat, desert, sand, and sweat. Gemstones are used in the Torah and Ark covers. The gems are sewn in and silver and gold filigree threads are used. In *Beckett in Prague* (1994), demonic characters, plants, and animals—which were originally illustrated in accord with the injunction not to depict the human form—surround the literary figure. What I have done is to throw Beckett into a second- or third-century admonition.

SF: There is a leveling effect with the religious and secular imagery in your work. Architecture, barbed wire, a commonplace chair, a crematorium door—all seem to function at a fundamental level as evidence and forms.

HB: In the end, all forms and objects in my pictorial repertoire issue from the same sensibility. Disparate forms will keep company and cohabit on the same flat surface. Rearranged, they emit different signals and evoke new meanings and discourse.

As a curious ironic side, in the lower quadrant of the Nightwork *Poyln: Topf* (2000), two forms coexist: a decorative ancient synagogue door with the letter *Z* and a large hinged crematorium door emblazoned with the word "topf." Decades after World War II, Topf manufacturers sought reparations and sued for damages to their crematoria from Allied bombing and being blown up by internees who revolted in the camps.

SF: The knowledge that we bring to the interpretation of objects is important for understanding your work. For instance, what does it mean for a lawyer, who is also a collector, to sit in a high modernist chair and to have Douglas Schultz, the retired director of the Albright-Knox Art Gallery, in a movie director's chair? It's a joke in a way. Everyone comes to your work with different sets of knowledge, which determine the outcome.

HB: As the great imponderable, meaning and interpretation are variable and reside in the senses. Visual phenomena, even when clothed in recognizable and describable forms, may defy rational explanation. But they demand prolonged looking and an attempt at verbal discourse. My pictorial representations conjure up particularized and hypothetical worlds of the imagination, allowing me to explore memory. The writer Carlos Fuentes, on seeing some of my sketchbook drawings, stated again and again ". . . remember the future; imagine the past."

Endnote:
1. In an interview with the novelist Julián Ríos, Kitaj compares his painterly compositions to the poet John Ashbery's literary syntax as distinctly "Americanized, expatriated Surreal-Symbolism" that connects "unusual, variable worlds, emotions, phrasing, words, etc." Kitaj further states: "Like me, he seems to want to do something anachronistic, undecidable, different with every picture." Quoted in Julián Ríos, *Kitaj: Pictures and Conversations* (London: Hamish Hamilton, 1994), 67. It is these unanticipated combinations of people with everyday and unexpected objects—grounded in a literary aesthetics of human discourse and interaction—that arguably relate Breverman's artwork to that of Kitaj.

HARVEY'S HIP

Beauty's in eye of the proverbial beholder,

but when you're older,

you get bolder.

Harvey says, "Hold still, bro, so I can get you,

let me look hard at you, stare at you, see what you

never thought I'd know how to!"

It all fits into his impeccable scheme

like dreams find room for one and all it seems,

and "inside out" is what it always seems to mean.

Harvey knows—from the hair on your head

to the bottoms of your shoes, to what you do in bed—

even who you were talking to and what they said.

— Robert Creeley, 2004

PAINTINGS & DRAWINGS

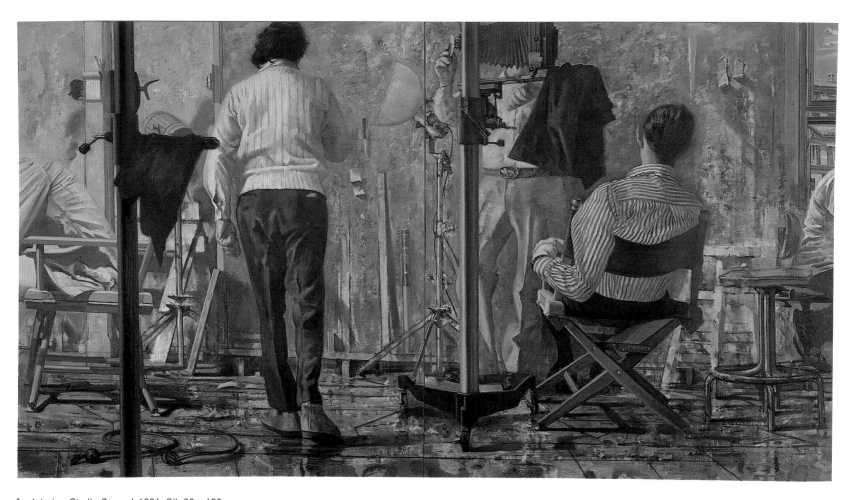

1. *Interior: Studio Group I*, 1991, Oil, 66 x 120

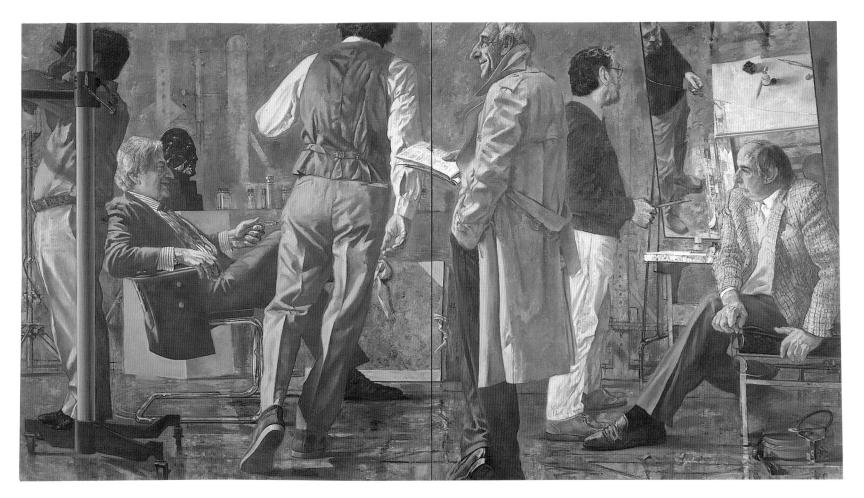

2. *Interior: Studio Group II*, 1991, Oil, 66 x 120

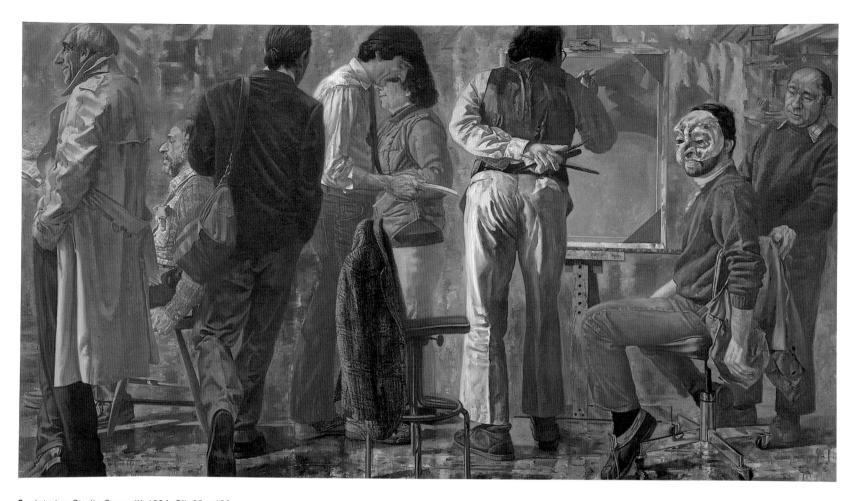

3. *Interior: Studio Group III*, 1994, Oil, 66 x 120

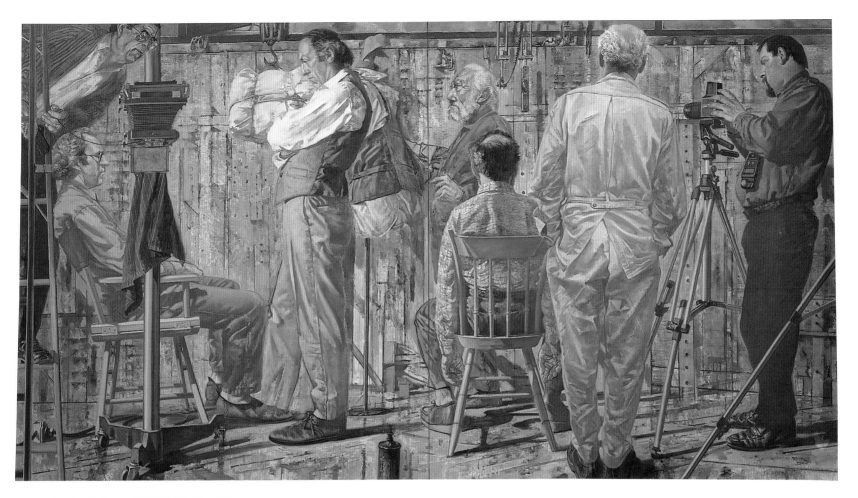

4. *Interior: Studio Group IV*, 1997, Oil, 66 x 120

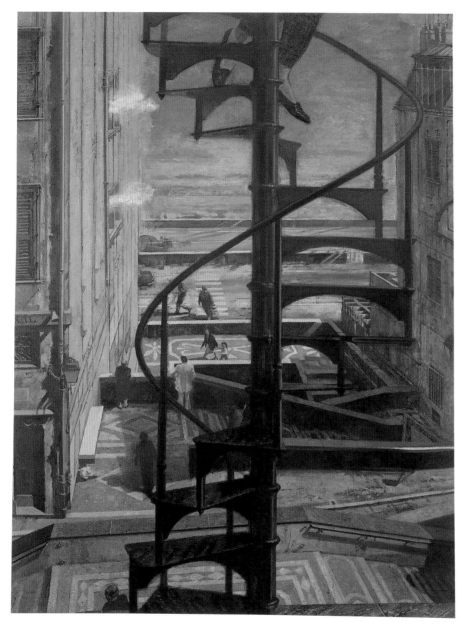

5. *Exterior: Menton*, 1995, Oil, 72 x 54

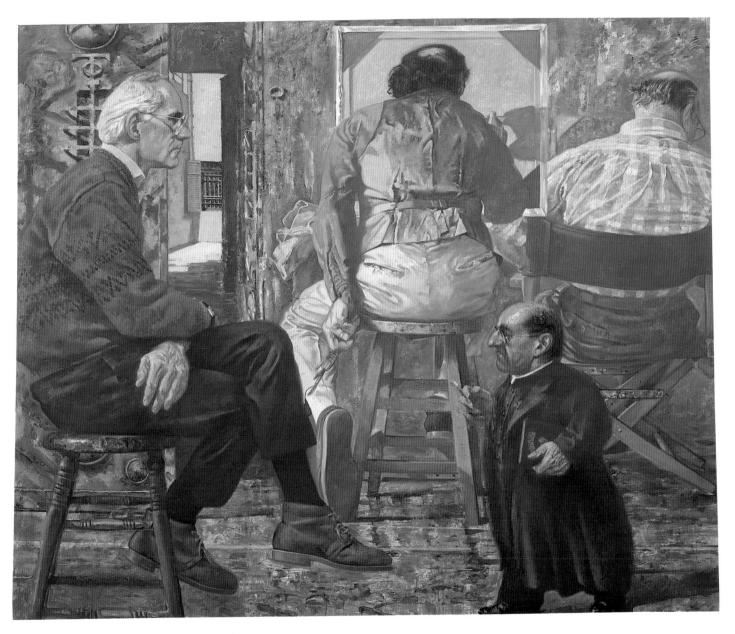

6. *The Green Book of Aragon II*, 1992, Oil, 60 x 72

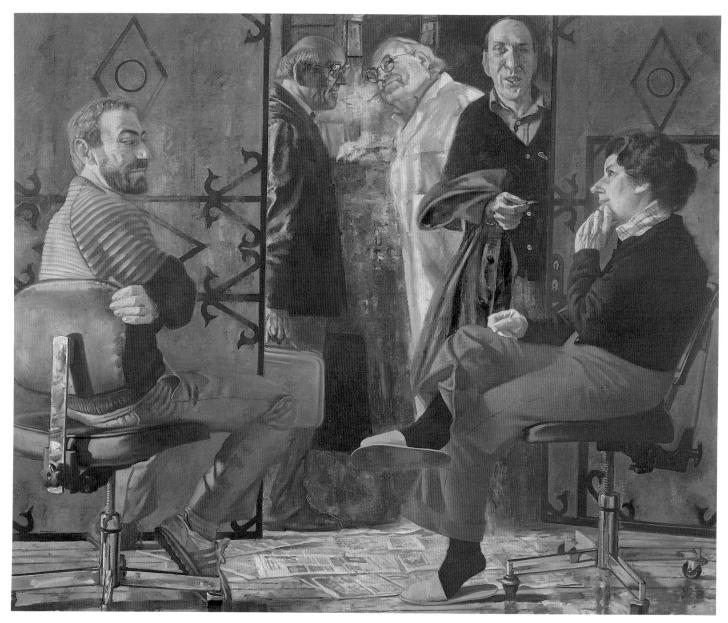

7. *Doorway in Jerusalem I*, 1991, Oil, 60 x 72

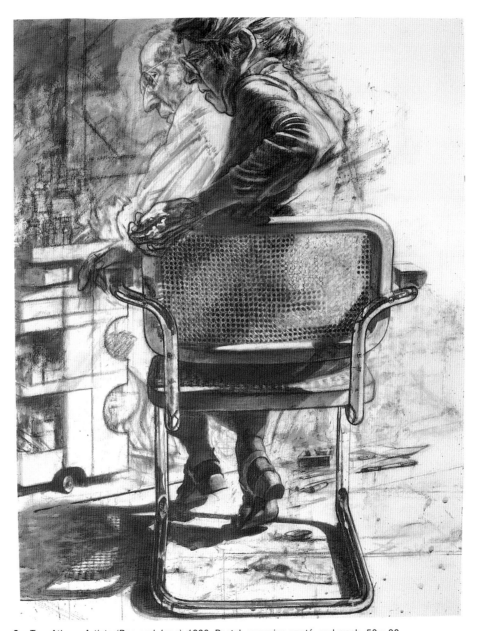

8. *Two Athens Artists (Don and June)*, 1986, Pastel, sanguine conté, and wash, 50 x 38

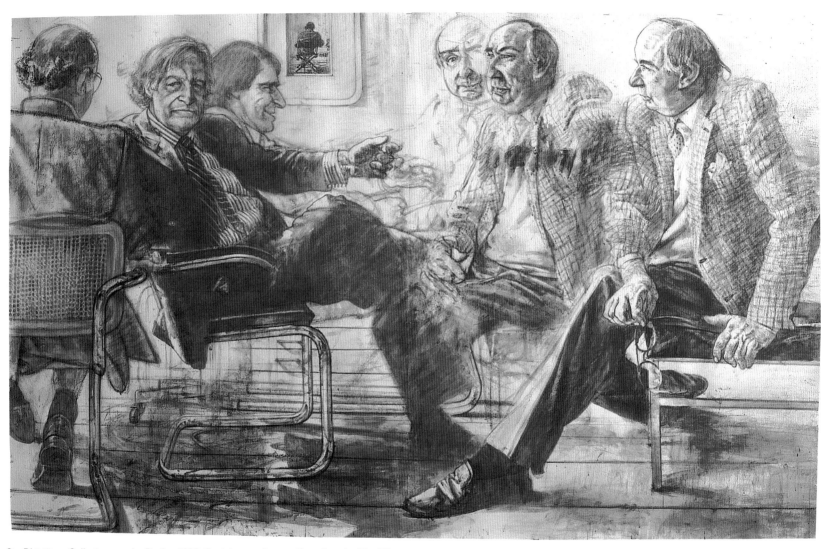

9. *Directors, Collectors, and a Dealer*, 1989, Pastel, sanguine conté, and wash, 48 x 76

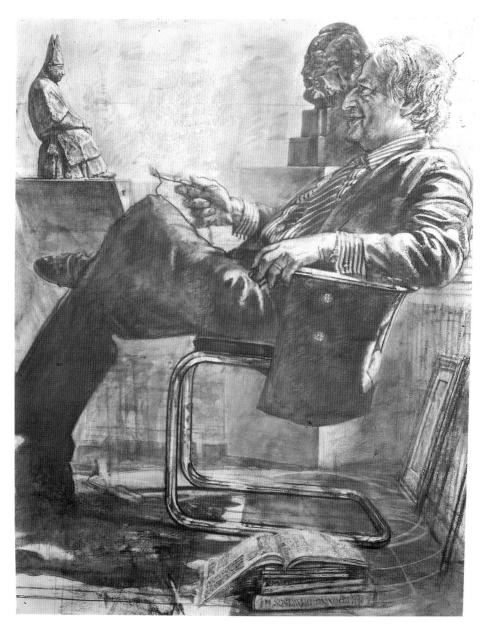

10. *The Dealer and the Cardinal*, 1988, Pastel, sanguine conté, and wash, 50 x 38
Collection of James and Katherine Goodman

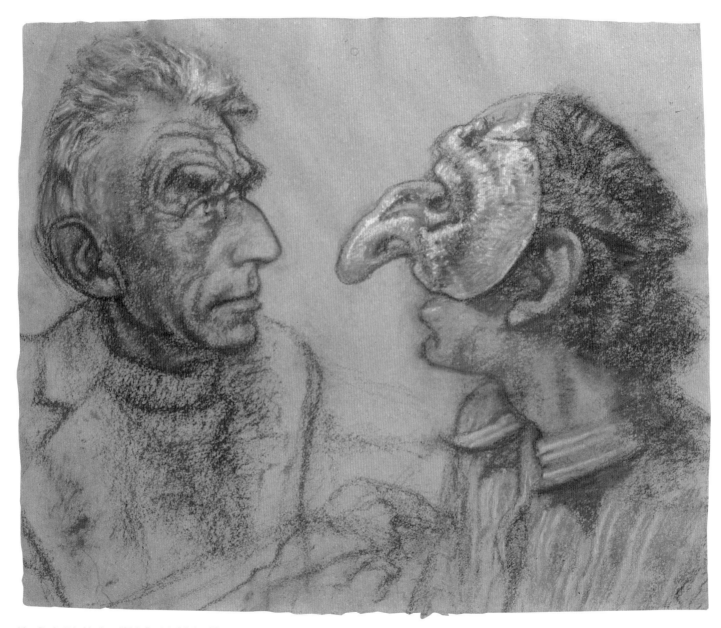

11. *Beckett in Venice*, 1984, Pastel, 24 ¼ x 20

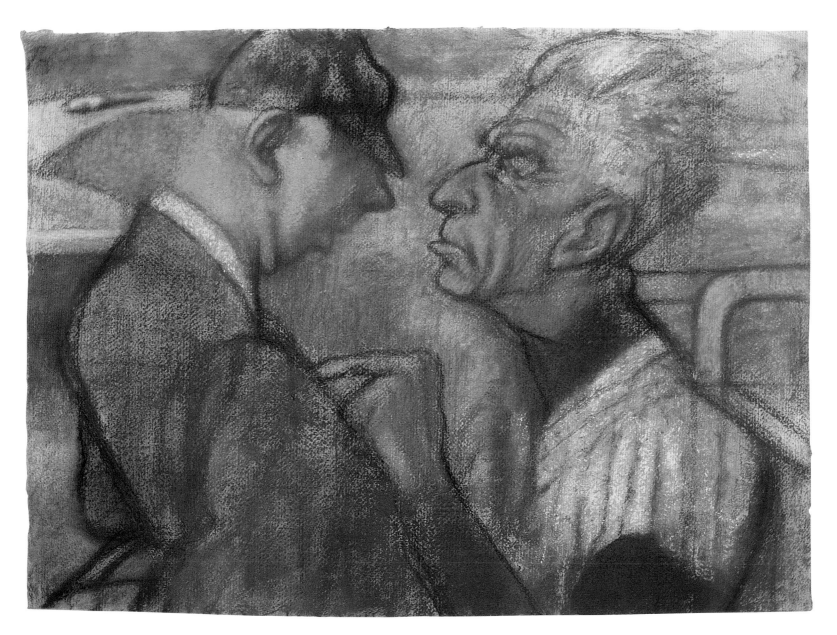

12. *Beckett and Baseball*, 1986, Pastel, 32 x 30 ¾
Collection of Dr. Paul and Joyce Chapnick

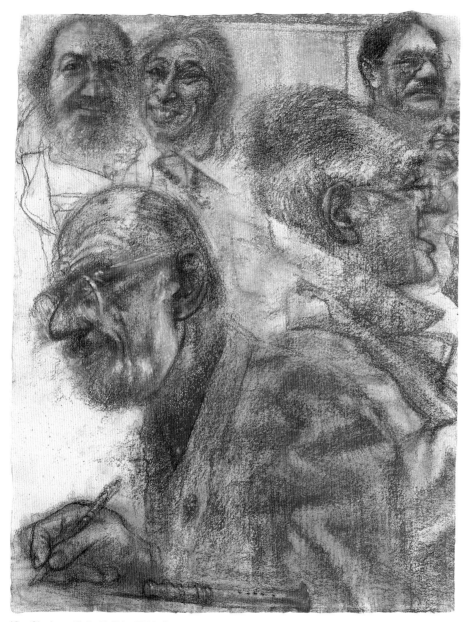

13. *Ginsberg Visits Buffalo*, 2003, Pastel, 26 x 19 ½

THE HUMAN PRESENCE

raymond federman

what interests me what has always interested me when looking at paintings is not so
much the subject (figures/objects) represented but the space in which the subject is
situated the way the space around the subject inside the subject is constructed organized or
deconstructed disorganized and to what extent that space in all its complexity or
simplicity relates to the subject affects it or how that space in abstract paintings affects
itself when the subject has disappeared and space sustains its own irrationality

what attracts me fascinates me in harvey breverman's paintings is the way he uses abuses
space the subjects are still there (human figures who dare turn their backs on us with
effrontery while contemplating the very space which sustains them or coats emptied of
their human inhabitants and which defy the space in which they hang) but what makes
these figures and coats fascinating is the way they occupy space and how suddenly by
their absurd presence they render that space utterly illogical irrational while at the same
time these seemingly realistic figures and coats become surrealistic

Nardin Galleries, New York, 1980

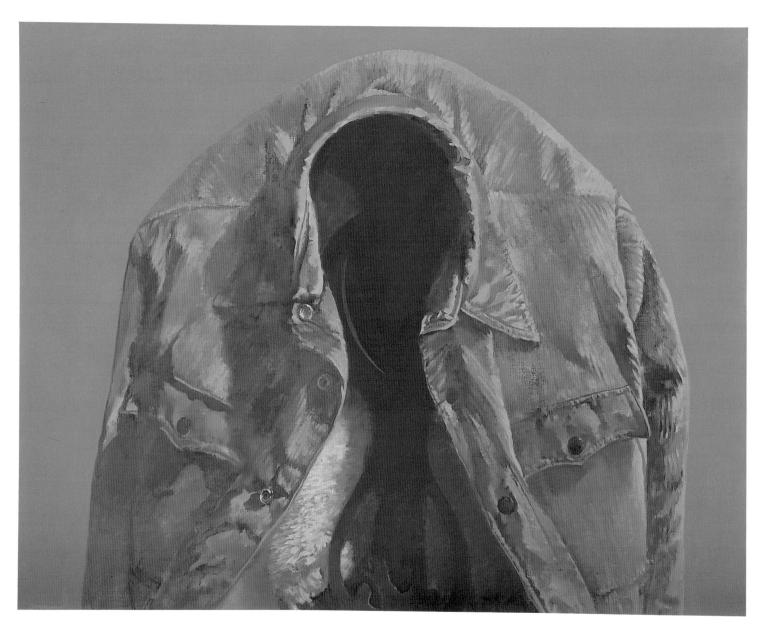

14. *Corduroy Jacket*, 1977, Oil, 38 x 48
Collection of Mark Chason and Mariana Botero Chason

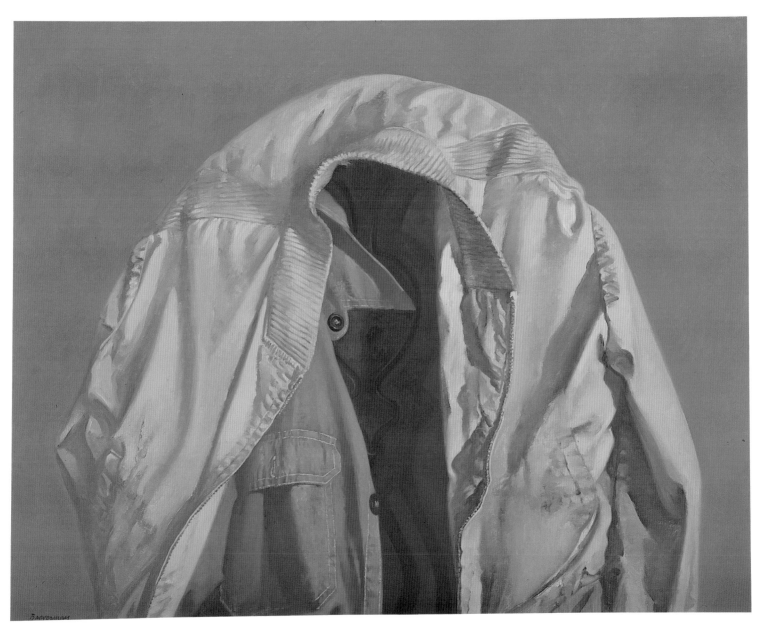

15. *Eggshell Jacket (Second Version)*, 1978, Oil, 38 x 48

MYSTERY OF A PRAYER SHAWL SERIES

Sylvia A. Herskowitz

Immediately after birth, we are wrapped in cloth—perhaps the most pervasive of the rituals that accompany us through life—until the moment of our death, when we are wrapped again. Is it for this reason that the act of wrapping oneself in a tallit—prayer shawl as the initial act of praying resonates with meaning? The prayer that observant Jews utter every morning when they don the tallit refers to God wrapping Himself in light as a garment and goes on to state "I am wrapping myself in the fringed garment in order to fulfill the command of my Creator."

Enveloping oneself in a sacred cloth in itself seems to confer sanctity on a person—something awesome—otherworldly. Even so trivialized an image as Chagall's *The Praying Jew* enveloped in his tallit, still exerts a powerful pull on all of us, its spirituality strengthened by the rabbi's gaunt face and the mysterious tefillin on his forehead.

Although Harvey Breverman's portraits of prayer shawls have no face, they are brimming with meaning. Portrayed from the back, the way they appear to him in the synagogue, they distinguish themselves despite hanging from anonymous shoulders; draping themselves languidly around nameless backs with accustomed familiarity, falling gently into folds that transform their precisely ordered stripes into acute and oblique angled patterns of black and white.

Only a confident, self-assured draftsman like Breverman could bestow on these faceless portraits such an emotional range. We know that Breverman loves to draw fabric. Drawing, he says, has an excitement he can't get out of his skin. And he also loves material—loves doing folds and creases. He has drawn self-portraits of his jackets which he calls a surrogate for his presence. He waxes eloquent about these jacket portraits—how the jacket drapes over a chair given its natural material and its weight—how it sits in a certain light and shade arrangement.

In his tallit portraits Breverman offers us well-worn woolens redolent with human warmth and scent, their fibres having a long and intimate relationship with the owners' necks, shoulders, and backs. Breverman presents them largely in monochrome, drawing with pastel and conté crayon. He comments: "For many years I stood (praying) behind other people, in rows and it never occurred to me that seeing what happened in front of me could be part of my life's work, at the same time that I could be an active participant in the ritual of praying . . . So I use a prayer shawl . . . as a metaphor for exhilaration, suffering, joy, fear—all sorts of things,— and it can't leave me."

Yeshiva University Museum, 1997

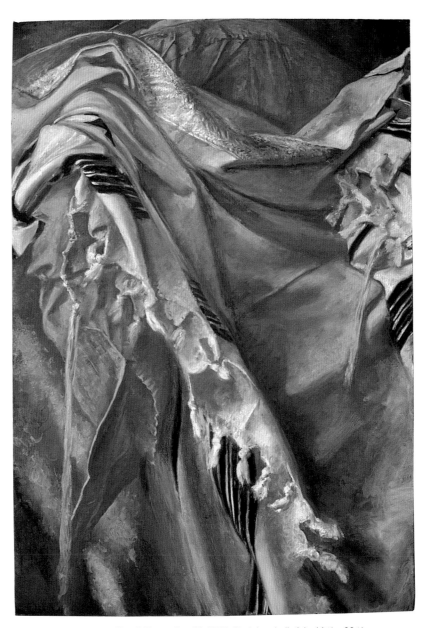

16. *Mystery of a Prayer Shawl (Ascension III)*, 1986, Pastel and oilstick, 44 ½ x 30 ¼

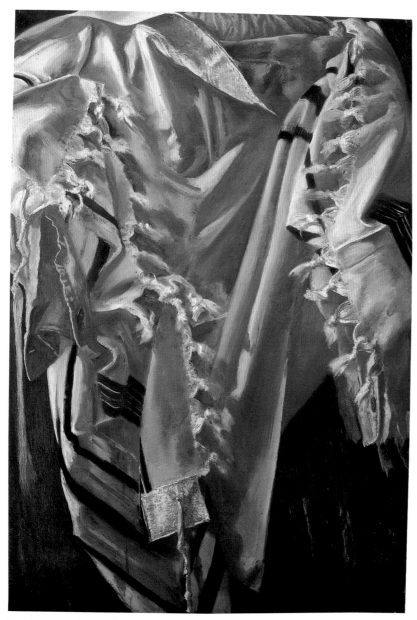

17. *Mystery of a Prayer Shawl (Himmelweg II)*, 1990, Pastel and oil pastel, 44 ½ x 30 ¼
Collection of Kenneth and Antoinette Dauber

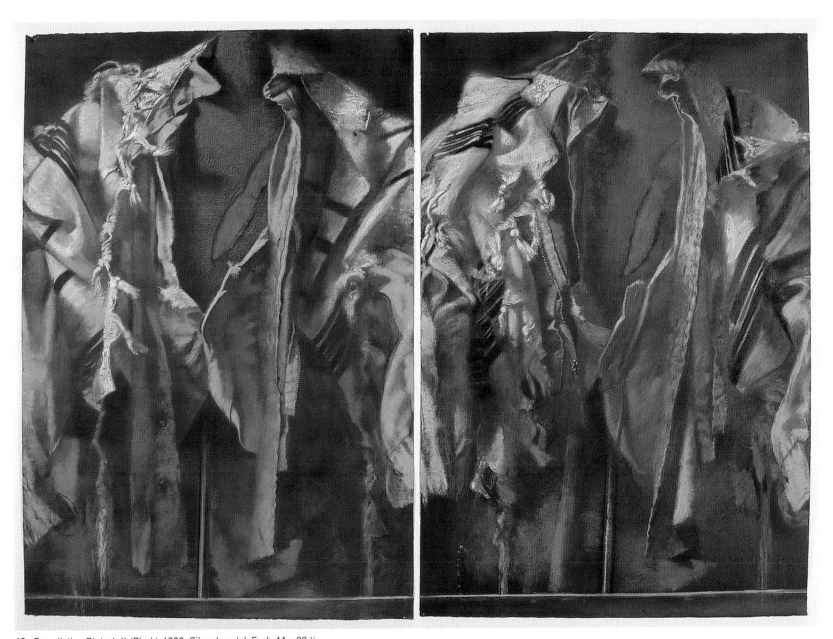

18. *Benediction Diptych II (Black)*, 1986, Oil and pastel, Each 44 x 30 ¾

THE NIGHTWORKS SERIES: 40 WORKS ON PAPER

Stephanie L. Taylor

In the black-and-white, silent documentary film, the machine moved swiftly down the railroad tracks, slicing the ties that bound them in an easy motion, like a zipper, effortlessly rendering that form of transportation and communication defunct. This industrial sabotage, accomplished by Nazi soldiers following Hitler's orders at the close of WWII, was part of the plan to lay waste to Berlin before the arrival of the Allied forces. It was only recently that this image was added to my personal bank of world history visual memory, and the beauty contained in this elegant destruction was surprising. Its power moved me.

After reading the Diary of Anne Frank as an adolescent and steeping myself in popular culture depictions of the era (from the kitsch of television's *Hogan's Heroes* to the more serious, though still Hollywood, epic *Schindler's List*); after visiting contemporary Holocaust memorials and museums; after viewing film footage of the concentration camps being liberated, and studying still images of dead SS guards, a suicided bureaucrat's family in Leipzig, and the lovely Surrealist muse/photographer/war correspondent, Lee Miller, taking a bath in the Führer's private bunker; after all of this, it is the simple image of a single strand of wire floating in one of the drawings from Harvey Breverman's Nightworks series that captures and holds my attention. It, too, has the power to move. The barbed wire makes me wonder if I am viewing this work from a position within or outside of the implied barrier. Am I part of this historic tragedy, or am I simply an observer?

Beyond the barbs of wire, Breverman gives us clues to orient us to the vast subject of his work. Yellow stars appear, sometimes as central imagery and at other times as background information, along with bits of striped cloth, prosthetic limbs wrapped in leather T'Fillin straps, and, yes, even railroad tracks. The lost wooden synagogues of Poland's past are hinted at through the skeleton-ribbed renderings in some of the drawings, while fragments of more detailed architectural elements are included in others. Flames burst from windows, and black smoke sometimes billows and spreads above them.

Each of us brings layers of knowledge and lives full of visual imagery to the subject of the Holocaust. In his drawings, Harvey Breverman presents those layers in thick slabs of imagery that straddle the borders between real and abstract, between private and public. Like May Stevens, who explores the difference between the lives led by her mother, a typical American housewife, and the German Marxist political martyr, Rosa Luxemburg, and similar to Francis Bacon's gripping portrayals of a faceless and tormented post-War humanity, Breverman makes connections in his drawings between the personal and the historical. It is through this fusion that he creates possibilities for the inclusion of the past in our contemporary lives.

The layering of images and memories is repeated in Breverman's technique. He starts with black paper and, often, a highly abstract application of a field of color. To this he adds transfers and tracings and free-hand design elements. Like an intaglio print, Breverman builds his drawings up from the paper surface in stages. They are scraped, dripped, burnished and smeared: they are rife with information, and crowded with ideas.

Breverman's skillful use of pastel and oilstick, among other diverse media, renders icons for the present day, complete with set jewels, calligraphic labels and illuminated borders. These layers of references, amassed from biblical (and other) texts and ceremonial objects, surround the portraits featured in many of these works, images of Robert Creeley, Jim Dine, Robert Duncan, Raymond Federman, and Allen Ginsberg, men whose names are familiar even if their faces are not. They are Breverman's colleagues, compatriots and close friends, and all but the portraits of Samuel Beckett and Primo Levi were drawn from life. And while several of his portrait subjects stare inward, or upward, or close their eyes in an apparent refusal to acknowledge the viewer, the rich surfaces of Harvey Breverman's drawings are infinitely attractive, bordering on delicious, and they engage us utterly.

Indiana University School of Fine Arts Gallery, 2001
Ohio University Art Gallery, 2002

NIGHTWORKS

19. *Coetzee in Prague*, 1994, Pastel and oilstick, 39 ½ x 27 ¾

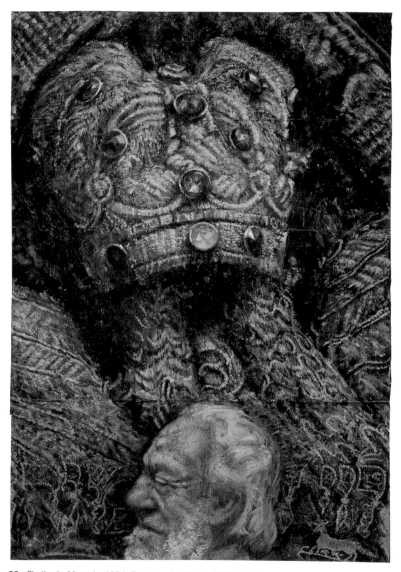

20. *Fiedler in Moravia*, 1994, Pastel and oilstick, 39 ½ x 27 ¾

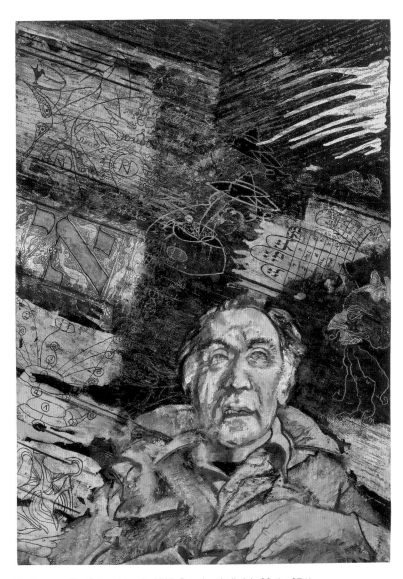

21. *Duncan: The Schwa Vowels*, 1999, Pastel and oilstick, 39 ½ x 27 ¾

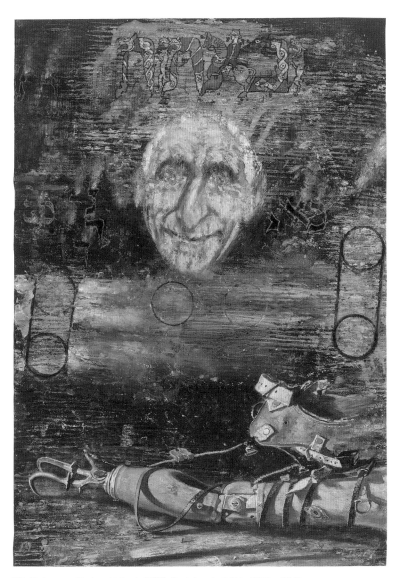

22. *Federman: Broken Epitaph*, 2000, Pastel and oilstick, 39 ½ x 27 ¾

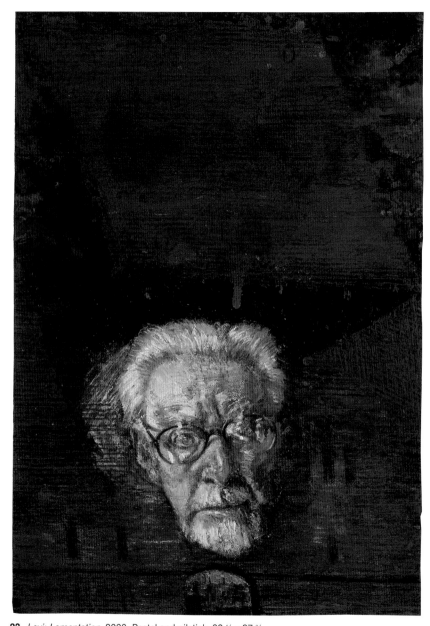

23. *Levi: Lamentation*, 2000, Pastel and oilstick, 39 ½ x 27 ¾

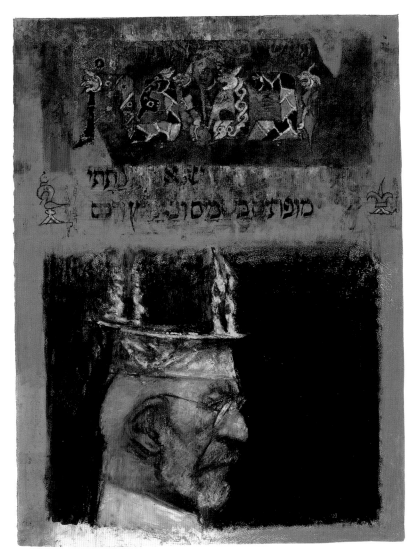

24. *Dine: In Catalonia*, 1999, Oilstick, 30 x 22

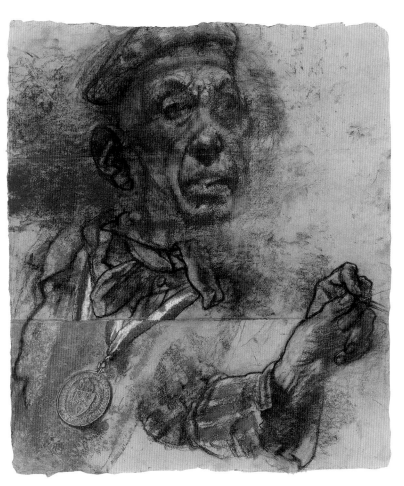

25. *The D.P.*, 2002, Pastel, 29 x 25

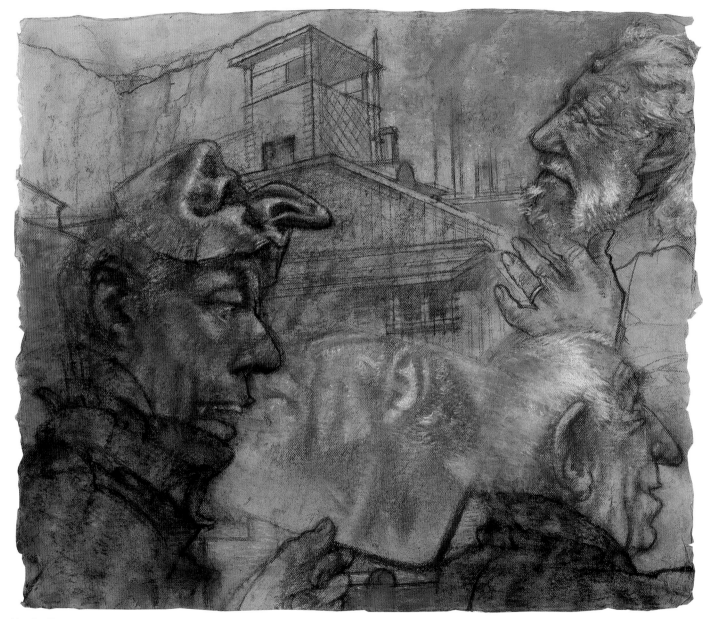

26. *The Block I*, 2002, Pastel, 25 x 28 ½

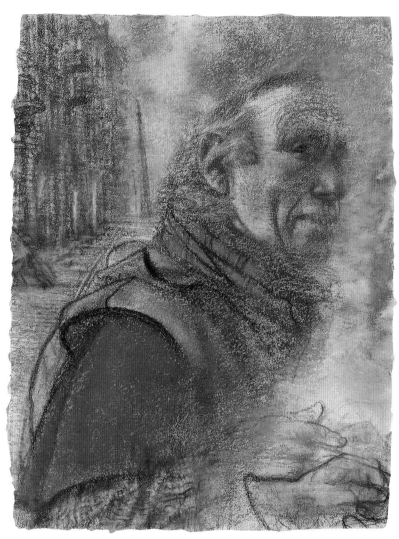

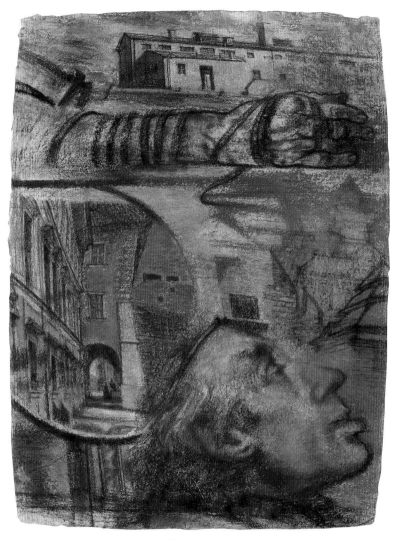

27. *Nights in Warsaw II*, 2003, Pastel, 31 x 23

28. *Prague: Tefillin*, 2003, Pastel, 31 x 23

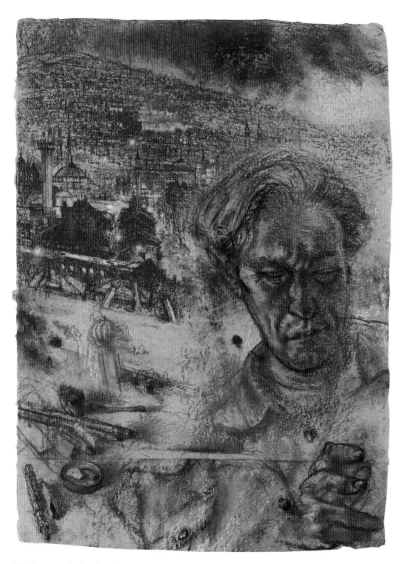

29. *Contemplating Sarajevo I*, 2003, Pastel, 31 x 23

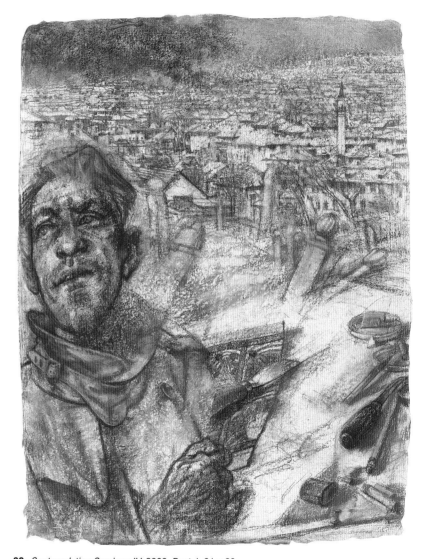

30. *Contemplating Sarajevo IV*, 2003, Pastel, 31 x 23

PRINTS

Always armed with a sketchbook and his hawklike gaze, he bravely,

empathically documents those around him: poets, artists, academics,

the fellow on this street caught in the draftsman's cross hairs. Once, at an

exhibition of his work at the University of New Hampshire, Harvey agreed to

make a full-sheet portrait drawing in front of our faculty and students. Seated in

front of his sitter, working at breakneck speed, using an array of tools and his

fingers, magically the page came to life. He kept creeping in closer and closer,

so close in fact, that the model ended up holding Harvey's large drawing board

with both his hands as the artist's nose almost touched the model's.

—Sigmund Abeles, 2004

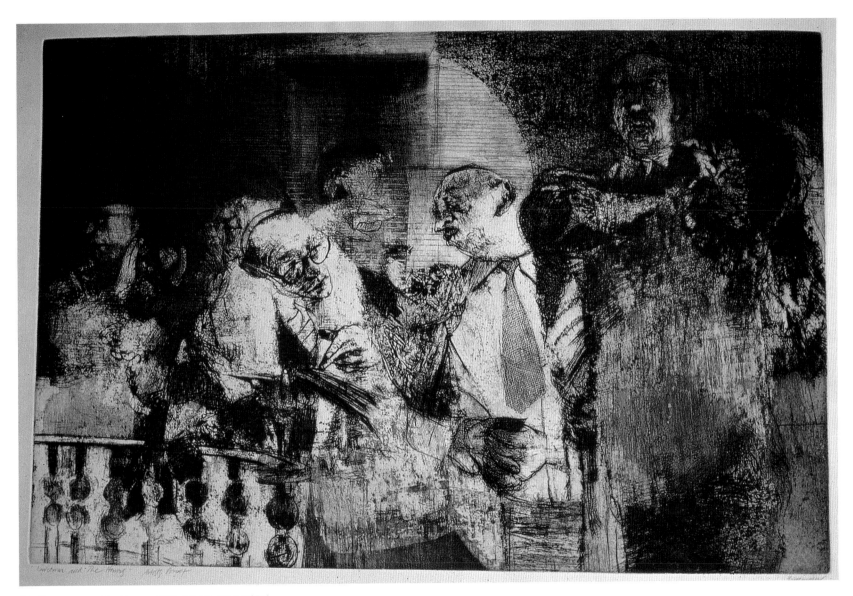

31. *Newcomer and the Honors*, 1965, Intaglio, 23 ¼ x 35 ½
Collection of Morton G. Rivo, Mill Valley, California

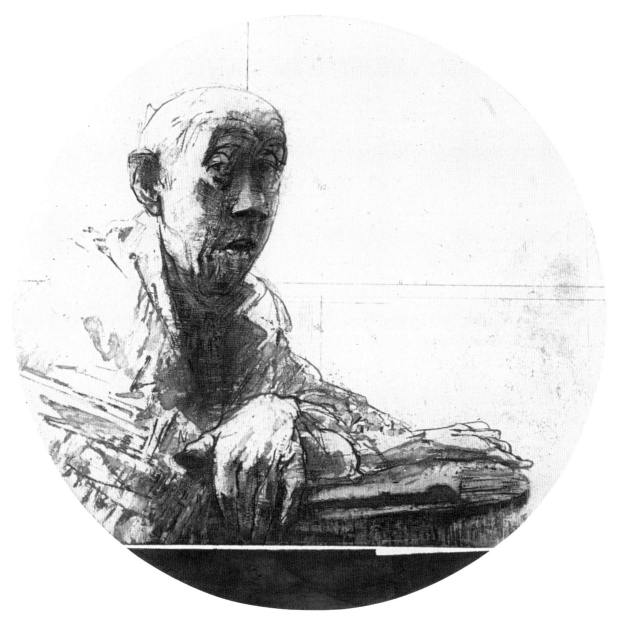

32. *Dutchman II*, 1967, Intaglio, 23 ¼ diameter
Collection of Phillip and Judy Brothman, Williamsville, NY

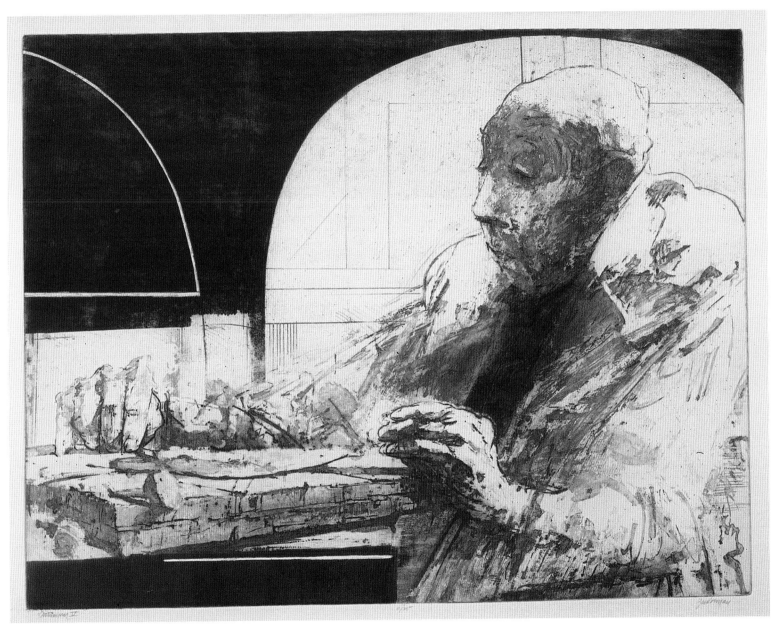

33. *Dutchman V*, 1967, Intaglio, 21 ¾ x 28
Collection of Annette and Joseph Masling

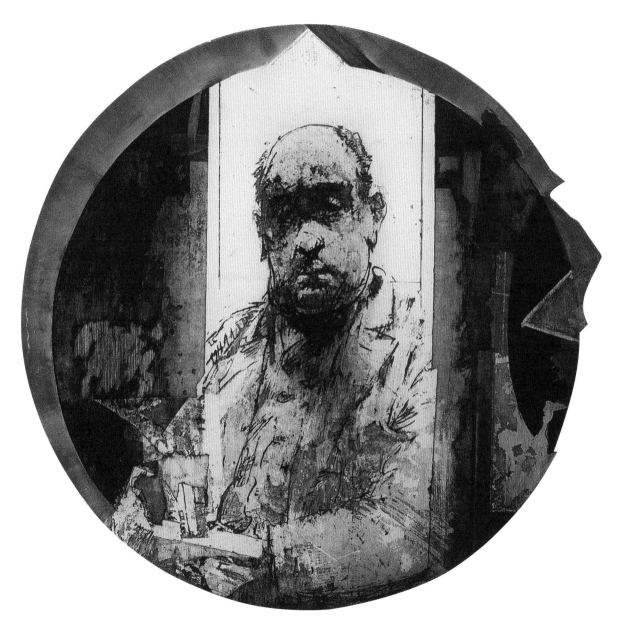

34. *Brooding Figure*, 1968, Intaglio, 23 ½ diameter
Collection of Sue and Gerald Strauss

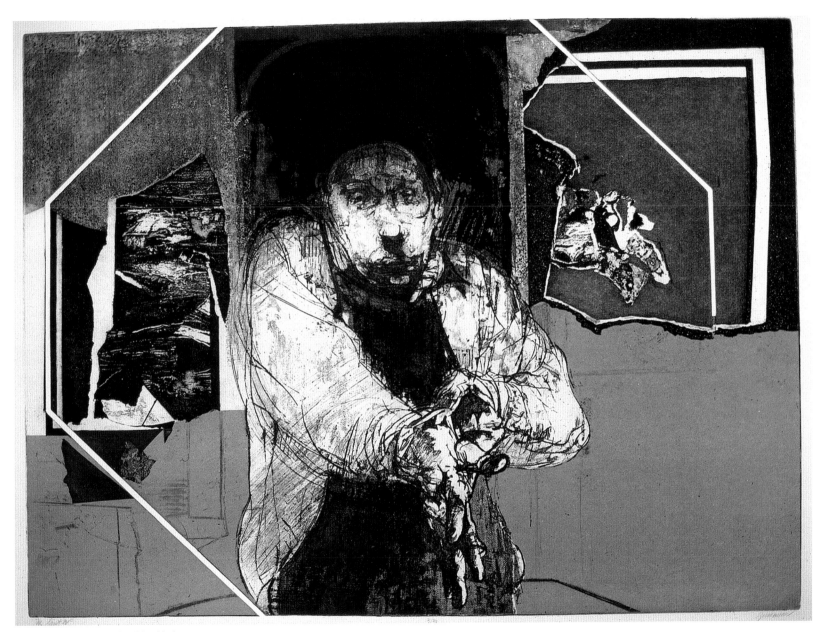

35. *The Printer*, 1970, Intaglio, 22 x 29 ½
Collection of John W. and Pamela M. Henrich, Eden, NY

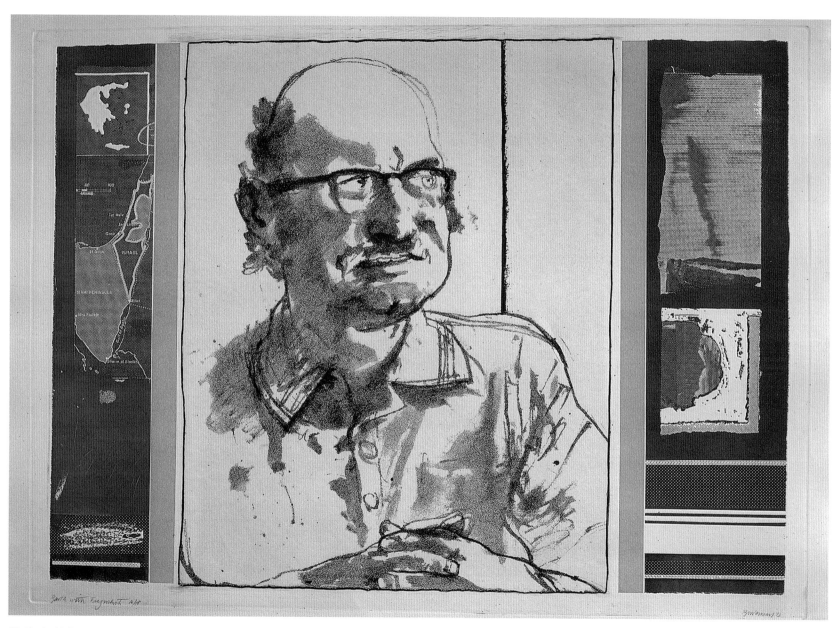

36. *Barth with Fragments*, 1973, Intaglio, 23 ¼ x 31 ¾
 Collection of Mr. and Mrs. William M. E. Clarkson

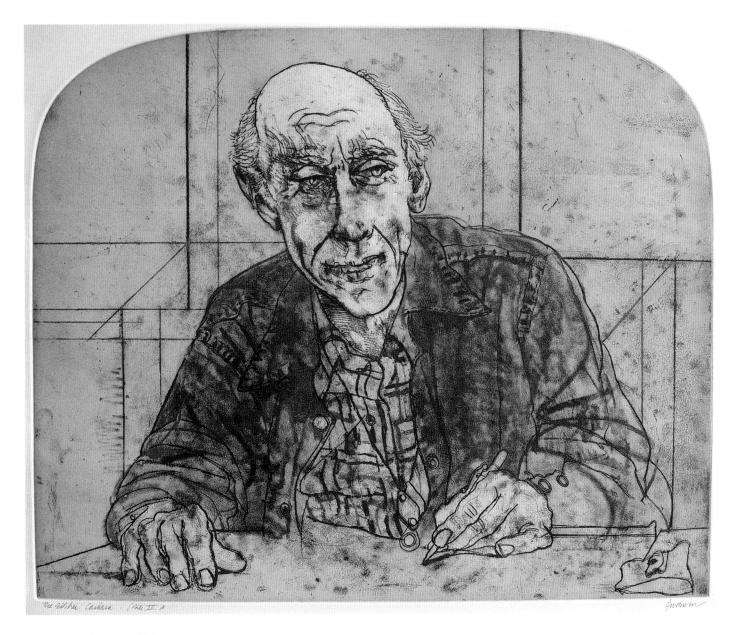

37. *The Etcher Cassara*, 1980, Intaglio, 19 ¾ x 23 ½
Collection of Dr. and Mrs. Marshall Fagin

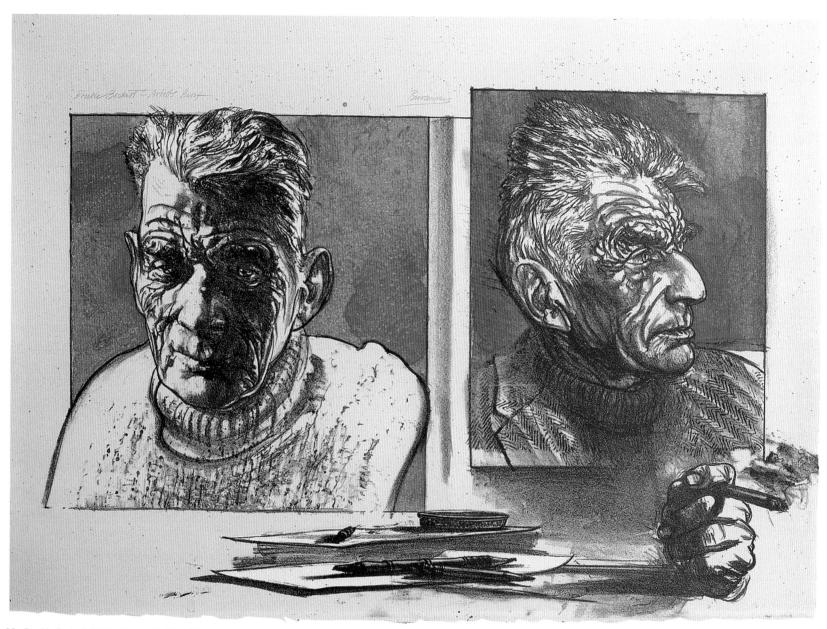

38. *Double Beckett*, 1985, Lithograph, 22 x 30
Collection of Frederic P. and Alexandra B. Norton

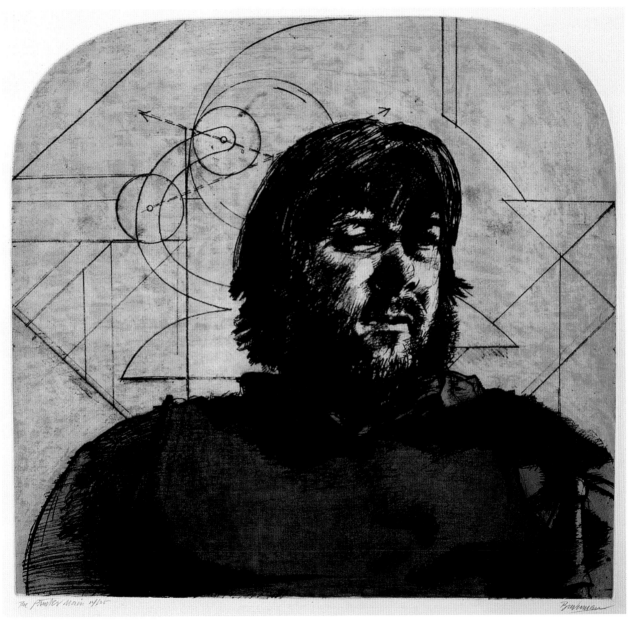

39. *The Printer Morin*, 1986, Intaglio, 22 ¼ x 23 ¾
Fine Arts Musuems of San Francisco; Gift of Dr. Morton G. Rivo

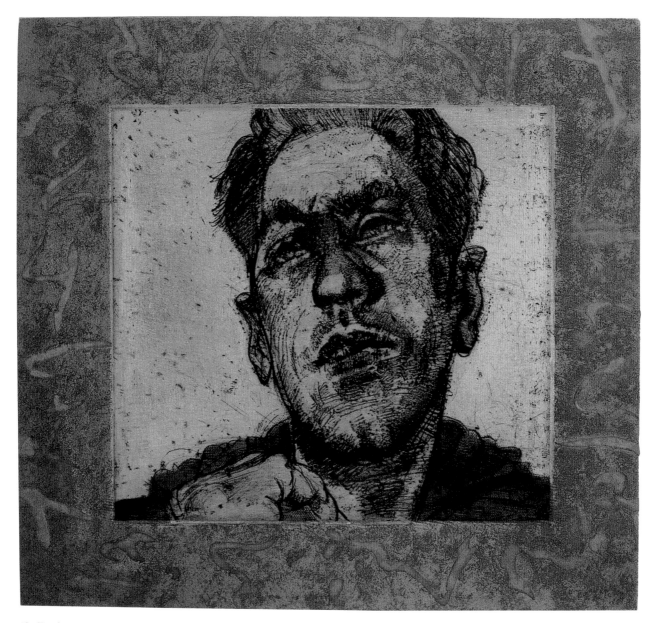

40. *The Sarajevan*, 1995, Intaglio, 15 ¾ x 17

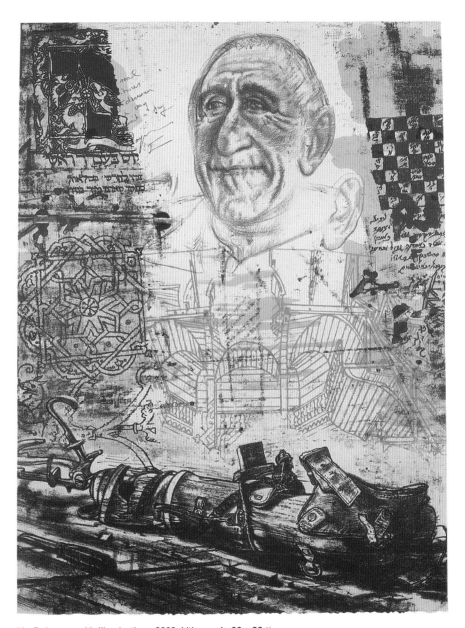

41. *Federman with Illuminations*, 2003, Lithograph, 30 x 22 ¼

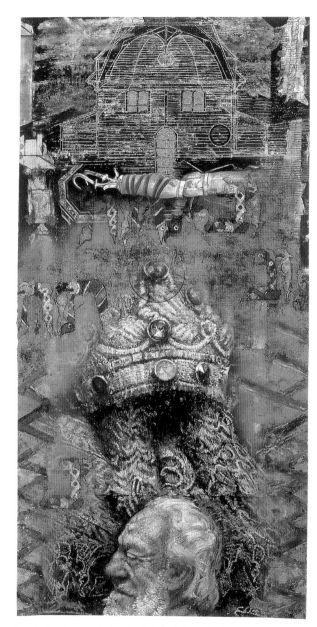

42. *Fiedler: Composite*, 2003, Digital print, 58 ¾ x 27 ¾

CHECKLIST

Works are loaned from the artist, unless othersize noted. All dimensions are image size in inches, height preceding width.

• denotes an illustration

PAINTINGS & DRAWINGS

• 1. *Corduroy Jacket*, 1977
Oil
38 x 48
Collection of Mark Chason and
Mariana Botero Chason
(Plate 14)

2. *Eggshell Jacket*, 1977
Oil
36 x 46
Collection of Mr. and Mrs.
Richard Gordon, Buffalo, NY

3. *Jacket with Green Shirt*, 1977
Pastel
22 x 30
Collection of Julie Freudenheim
and Spencer Feldman

4. *Morganza's Golden Interior*,
1977
Oil
50 x 66
Collection of Martha and
David Dunkelman

5. *Silver Green Jacket*, 1977
Oil
38 x 48

6. *Suede Jacket*, 1977
Oil
38 x 48

• 7. *Eggshell Jacket
(Second Version)*, 1978
Oil
38 x 48
(Plate 15)

8. *Orange Jacket*, 1978
Oil
38 x 48
Collection of Pauline and
Richard Brummer

9. *The Dandy I*, 1980
Pastel
31 x 23
National Academy of Design,
New York

• 10. *Interior of an Exterior:
Avignon I*, 1980
Oil
66 x 54
(Figure 3)

11. *Interior of an Exterior:
Avignon II*, 1981
Oil
66 x 50

12. *The Quilted Jacket*, 1981
Pastel
31 x 23
Collection of Elizabeth and
Peter Tower

13. *Two Jews in Tangier I*, 1981
Pastel, sanguine conté,
and wash
48 x 76
Collection of Betty and
Irving Korn

14. *Figure Back, Canvas Back*,
1982
Pastel, sanguine conté,
and wash
48 x 38

• 15. *Interior: Four Rooms*, 1982
Pastel, sanguine conté,
and wash
48 x 76
(Figure 14)

16. *Interior: Two Seated Figures
VIII*, 1982
Pastel, sanguine, conté
and wash
48 x 76

17. *The Attorney (Howard)*, 1984
Pastel, sanguine conté,
and wash
50 x 38
Collection of Howard L. Yood

18. *Beckett and Serres
(Cordoba Light)*, 1984
Pastel
24 ¼ x 28

• 19. *Beckett as a Matador*, 1984
Pastel
31 x 23 ½
(Figure 15)

• 20. *Beckett in Venice*, 1984
Pastel
24 ¼ x 20
(Plate 11)

• 21. *Mélange*, 1984
Pastel, conté, charcoal,
and graphite
60 x 42
(Figure 9)

• 22. *Interior: The Drawing Lesson*,
1985
Pastel, sanguine conté,
and wash
48 x 76
(Figure 1)

• 23. *Beckett and Baseball*, 1986
Pastel
32 x 30 ¾
Collection of Dr. Paul and
Joyce Chapnick
(Plate 12)

24. *The Dandy II*, 1986
Pastel
31 x 23 ½

25. *Seated Figure Turning III
(Nick)*, 1986
Pastel, sanguine conté,
and wash
48 x 38

26. *Seated Figure Turning IV
(Sandy)*, 1986
Pastel, sanguine conté,
and wash
48 x 38

27. *Serres, Foucault, Beckett
(Paris Light)*, 1986
Pastel
31 x 23

• 28. *Two Athens Artists
(Don and June)*, 1986
Pastel, sanguine conté,
and wash
50 x 38
(Plate 8)

29. *The Director (Doug)*, 1987
Pastel, sanguine conté,
and wash
50 x 38

30. *Interior: The Studio IV*, 1987
Oil
54 x 66

• 31. *Interior: The Studio VI
(Homage)*, 1987
Oil
60 x 72
(Figure 13)

• 32. *Interior: The Studio VII*, 1987
Oil
54 x 72
(Figure 10)

33. *The Burberry Scarf*, 1988
Pastel
34 ½ x 22 ¾

34. *Chautauqua I*, 1988
Pastel
31 x 23

• 35. *The Dealer and the Cardinal*,
1988
Pastel, sanguine conté,
and wash
50 x 38
Collection of James and
Katherine Goodman
(Plate 10)

36. *In the Studio (Couple)*, 1988
Pastel and oilstick
40 ¾ x 23

37. *In the Studio (Palette)*, 1988
Pastel
28 x 24 ½

38. *S.P. in Checkered Shirt*, 1988
Pastel and conté
31 ¼ x 22 ¼
University at Buffalo
Foundation; Promised Gift of
David K. Anderson, 2001

• 39. *Directors, Collectors, and a
Dealer*, 1989
Pastel, sanguine conté,
and wash
48 x 76
(Plate 9)

40. *From the Studio II*, 1990
Pastel
30 x 22

41. *From the Studio III*, 1990
Pastel, conté, charcoal
28 ½ x 48

• 42. *Doorway in Jerusalem I*, 1991
Oil
60 x 72
(Plate 7)

43. *Doorway in Jerusalem II*, 1991
Oil
50 x 54

44. *Doorway in Jerusalem III*,
1991
Oil
50 x 52

• 45. *Interior: Studio Group I*, 1991
Oil
66 x 120
(Plate 1)

• 46. *Interior: Studio Group II*, 1991
Oil
66 x 120
(Plate 2)

47. *Interior: The Studio VIII
(Doug)*, 1991
Oil
66 x 60
Dicke Collection

• 48. *The Green Book of Aragon II*, 1992
Oil
60 x 72
(Plate 6)

• 49. *Interior: Studio Group III*, 1994
Oil
66 x 120
(Plate 3)

• 50. *Exterior: Menton*, 1995
Oil
72 x 54
(Plate 5)

51. *Interior-Exterior: Munich*, 1995
Oil
72 x 54

• 52. *Interior: Studio Group IV*, 1997
Oil
66 x 120
(Plate 4)

• 53. *Bruce Jackson*, 2003
Pastel and conté
22 x 30
(Figure 2)

54. *Creeley and Dine in Buffalo*, 2003
Pastel
26 x 19 ½

55. *The Creeleys (Bob and Pen)*, 2003
Pastel
21 ½ x 30 ½

56. *Diane Christian*, 2003
Pastel
23 x 31

57. *Duncan: Opening the Field*, 2003
Pastel, ink, and oilstick
30 x 44

• 58. *Federman (Rue Jacob)*, 2003
Pastel
23 x 31
(Figure 6)

• 59. *Ginsberg Visits Buffalo*, 2003
Pastel
26 x 19 ½
(Plate 13)

60. *Michael Parker*, 2003
Pastel and conté
23 x 31

MYSTERY OF A PRAYER SHAWL SERIES

61. *Benediction Diptych I (Sanguine)*, 1982
Oil and pastel
Each 40 x 30

62. *Mystery of a Prayer Shawl Triptych*, 1983
Pastel and sanguine conté
Each 44 x 30 ⅛

• 63. *Benediction Diptych II (Black)*, 1986
Oil and pastel
Each 44 x 30 ¾
(Plate 18)

64. *Mystery of a Prayer Shawl (Ascension I)*, 1986
Pastel and oilstick
44 ½ x 30 ¼

65. *Mystery of a Prayer Shawl (Ascension II)*, 1986
Pastel and conté
44 ½ x 30 ¼

66. *Mystery of a Prayer Shawl II (Black)*, 1986
Pastel and oil pastel
44 ½ x 30 ¼
Collection of Dr. Leonard and Judith Katz

• 67. *Mystery of a Prayer Shawl (Ascension III)*, 1986
Pastel and oilstick
44 ½ x 30 ¼
(Plate 16)

68. *Mystery of a Prayer Shawl (Brown)*, 1987
Pastel and oil pastel
44 ½ x 30 ¼
Private collection

69. *Mystery of a Prayer Shawl IV*, 1987
Pastel and oil pastel
44 ½ x 30 ¼
Collection of Carl and Ruby Green

70. *Mystery of a Prayer Shawl III (White)*, 1988
Pastel and oilstick
44 ½ x 30 ¼

• 71. *Mystery of a Prayer Shawl (Himmelweg II)*, 1990
Pastel and oil pastel
44 ½ x 30 ¼
Collection of Kenneth and Antoinette Dauber
(Plate 17)

72. *Mystery of a Prayer Shawl (Ascension IV)*, 1990
Pastel and oil pastel
44 ½ x 30 ¼

73. *Mystery of a Prayer Shawl (Himmelweg VII)*, 1991
Pastel and oil pastel
44 ½ x 30 ¼

NIGHTWORKS SERIES

74. *Prague Nights I (Pinkas)*, 1989
Pastel and oilstick
30 x 20 ½

75. *Prague Nights III (Pinkas)*, 1990
Pastel and oilstick
30 x 22

76. *Prague Nights IV (Altneushul)*, 1990
Pastel
28 ½ x 25

77. *A Scribe in Prague I*, 1990
Pastel and oilstick
30 x 22

78. *A Scribe in Prague II*, 1990
Pastel and oilstick
30 x 22

79. *Serres in Prague*, 1993
Pastel and oilstick
39 ½ x 27 ¾

80. *Terezín I*, 1993
Pastel and oilstick
60 x 44

81. *Terezín II*, 1993
Pastel and oilstick
60 x 44

• 82. *Terezín III*, 1993
Pastel and oilstick
60 x 44
(Figure 11)

83. *Terezín IV*, 1993
Pastel and oilstick
60 x 41

84. *Terezín V*, 1993
Pastel and oilstick
60 x 44

85. *Beckett in Prague*, 1994
Pastel and oilstick
39 ½ x 27 ¾

• 86. *Coetzee in Prague*, 1994
Pastel and oilstick
39 ½ x 27 ¾
(Plate 19)

• 87. *Fiedler in Moravia*, 1994
Pastel and oilstick
39 ½ x 27 ¾
(Plate 20)

88. *Federman in a Gilet*, 1995
Pastel and oilstick
39 ½ x 27 ¾

89. *Fiedler in Pont Aven*, 1995
Pastel and oilstick
39 ½ x 27 ¾

90. *S.P. in Moravia*, 1995
Pastel and oilstick
30 x 22

91. *Wimpel: Galicia*, 1995
Pastel and oilstick
39 ½ x 27 ¾

92. *Volpa II*, 1998
Pastel and oilstick
39 ½ x 27 ¾

93. *Abeles: Kol Nidre*, 1999
Oilstick
30 x 22

94. *Ashbery: Hiberno-Iberian*, 1999
Oilstick
30 x 22

• 95. *Barth: Brevarium Judaicum*, 1999
Pastel and oilstick
39 ½ x 27 ¾
(Figure 7)

96. *Creeley with Masoretic Notes*, 1999
Pastel and oilstick
39 ½ x 27 ¾

• 97. *Dine: In Catalonia*, 1999
Oilstick
30 x 22
(Plate 24)

• 98. *Duncan: The Schwa Vowels*, 1999
Pastel and oilstick
39 ½ x 27 ¾
(Plate 21)

• 99. *Federman: Kol Nidre Elegy*, 1999
Oilstick
30 x 22
(Figure 8)

100. *Ginsberg among the Geniza*, 1999
Pastel and oilstick
39 ½ x 27 ¾

101. *S.P. as a Berber*, 1999
Oilstick
30 x 22

• 102. *Federman: Broken Epitaph*, 2000
Pastel and oilstick
39 ½ x 27 ¾
(Plate 22)

• 103. *Levi: Lamentation*, 2000
Pastel and oilstick
39 ½ x 27 ¾
(Plate 23)

• 104. *Poyln: Grodno*, 2000
Pastel and oilstick
59 x 41
(Figure 12)

105. *Poyln: Sanok*, 2000
Pastel and oilstick
60 ¼ x 41 ¼

106. *Poyln: Sokolski*, 2000
Pastel and oilstick
60 ¼ x 41 ¼

107. *Poyln: Topf*, 2000
Pastel and oilstick
59 ¾ x 41 ¼

108. *Poyln: Łódź*, 2001
Pastel and oilstick
60 ¼ x 41 ¼

109. *Sacrifice I*, 2002
Pastel and oilstick
19 ¾ x 25 ½

• 110. *The Block I*, 2002
Pastel
25 x 28 ½
(Plate 26)

• 111. *The D.P.*, 2002
Pastel
29 x 25
(Plate 25)

112. *Contemplating Paris I*, 2003
Pastel
30 ½ x 22 ¾

• 113. *Contemplating Sarajevo I*, 2003
Pastel
31 x 23
(Plate 29)

114. *Contemplating Sarajevo II*,
2003
Pastel
31 x 23

115. *Contemplating Sarajevo III*,
2003
Pastel
31 x 22 ¼

• 116. *Contemplating Sarajevo IV*,
2003
Pastel
31 x 23
(Plate 30)

117. *Contemplating Sarajevo V*,
2003
Pastel and oilstick
29 ¾ x 22

118. *Himmelweg II*, 2002
Pastel
24 x 18 ½

• 119. *Nights in Warsaw II*, 2003
Pastel
31 x 23
(Plate 27)

• 120. *Prague: Tefillin*, 2003
Pastel
31 x 23
(Plate 28)

PRINTS

121. *Dubious Honor I*, 1964
Intaglio
12 x 11 ⅝

122. *Dubious Honor II*, 1964
Intaglio
23 ¾ x 17 ⅝
University at Buffalo
Foundation, 1995

123. *Figure with Tallis (small)*, 1964
Intaglio
13 ¾ x 10 ⅝

124. *Dispute*, 1965
Intaglio
27 ½ x 21 ¾
Collection of
Mrs. Harrison Swados

125. *Dubious Honor III*, 1965
Intaglio
27 ½ x 17
Albright-Knox Art Gallery,
Buffalo, New York; Gift of the
Members' Gallery

126. *Figure with Medallion*, 1965
Intaglio
28 x 22

127. *Manipulator*, 1965
Intaglio
26 x 17 ⅝
Collection of Mr. and
Mrs. Daniel Fogel

• 128. *Newcomer and the Honors*,
1965
Intaglio
23 ¼ x 35 ½
Collection of Morton G. Rivo,
Mill Valley, CA
(Plate 31)

129. *Dutch Interior*, 1967
Intaglio
21 ¾ x 27 ½
Private Collection

• 130. *Dutchman II*, 1967
Intaglio
23 ¼ diam.
Collection of Phillip and Judy
Brothman, Williamsville, NY
(Plate 32)

131. *Dutchman III*, 1967
Intaglio
10 ¾ diam
Collection of Ginger and
David Maiman

132. *Dutchman IV*, 1967
Intaglio
22 ¾ diam.

• 133. *Dutchman V*, 1967
Intaglio
21 ¾ x 28
Collection of Annette and
Joseph Masling
(Plate 33)

134. *Figure with Tallis XII*, 1967
Intaglio
21 ¼ diam.
Collection of Mr. and
Mrs. George Pearlman

135. *View of Acre*, 1967
Intaglio
18 ½ x 27 ¼
Collection of Joseph and
Rena Merrick

• 136. *Brooding Figure*, 1968
Intaglio
23 ½ diam.
Collection of Sue and
Gerald Strauss
(Plate 34)

137. *Dutchman VI*, 1969
Intaglio
10 ½ x 12

138. *Illinois Tableau I*, 1969
Intaglio
23 ⅝ x 17 ½

139. *Dan Hamberg with
Fragments II*, 1970
Screenprint
41 x 26

140. *Discourse*, 1970
Intaglio
25 x 21 ¾
Collection of Dr. and
Mrs. Michael Ram

141. *Dubious Honor with
Illuminations*, 1970
Lithograph
16 ½ x 25 ¾

142. *Illuminations*, 1970
Lithograph
19 x 10
Collection of Gerald C. Mead Jr.

143. *King of Kings*, 1970
Lithograph
27 ½ x 19

144. *Mischa Schneider with
Fragments II*, 1970
Screenprint
38 ½ x 26 ½

• 145. *The Printer*, 1970
Intaglio
22 x 29 ½
Collection of John W. and
Pamela M. Henrich, Eden, NY
(Plate 35)

146. *Two Men*, 1970
Intaglio
23 diam.

147. *Cabbalist*, 1971
Lithograph
18 ⅞ x 14
Collection of Ruth W. Setters

148. *Cynic*, 1971
Lithograph
27 x 18 ½

• 149. *Disputation*, 1971
Lithograph
28 ¾ x 19
Collection of Dr. and
Mrs. George R. Levine
(Figure 5)

150. *Time Sequence/Honig*, 1971
Lithograph
35 ½ x 25 ⅛
Kennedy Museum of Art,
Ohio University

• 151. *Dutchman in Rhodes*, 1972
Intaglio
23 x 34 ¾
(Figure 4)

152. *Figure Study with Fragments*,
1972
Intaglio and collage
28 ¾ x 23

• 153. *Barth with Fragments*, 1973
Intaglio
23 ¼ x 31 ¾
Collection of Mr. and
Mrs. William M. E. Clarkson
(Plate 36)

154. *Dan Hamberg with Fragments*,
1973
Intaglio with collage
23 x 28 ¾

155. *Study of John Wilson*, 1973
Lithograph
29 x 19
Kalamazoo Institute of Arts;
Gift of Dr. and
Mrs. Frederick P. Nause

156. *Study of Leslie Fiedler*, 1973
Intaglio
23 ¼ x 31 ¾

157. *Study of Mischa Schneider II*,
1973
Intaglio and silkscreen
24 ⅞ x 24 ⅞

158. *Study of Creeley*, 1974
Intaglio
23 x 31 ¼
Collection of Kevin and
Joanna Ransom

159. *Study of Creeley (small)*, 1974
Intaglio
5 ½ x 7

160. *Study of Redgrove*, 1974
Screenprint
21 x 28 ½

161. *Study of Thom O'Connor*, 1974
Lithograph
11 ½ x 10 ¾

162. *Seated Figure in Profile*, 1975
Intaglio
7 ¾ x 9 ¾
Collection of Paul and
Janet McKenna

163. *Seated Figure in Red*, 1975
Intaglio
7 x 9 ⅞
Collection of Phillip and
Judy Brothman, Williamsville, NY

164. *Standing Figure in Profile*, 1975
Intaglio
6 ¾ x 9 ¼
Collection of Paul and
Janet McKenna

165. *The Draftsman*, 1976
Lithograph
20 x 29
Kalamazoo Institute of Arts;
Gift of Mrs. Deborah
Breverman

166. *English Poet (Ruthven Todd)*,
1977
Lithograph
22 x 30

167. *Literary Critic (Dwight
MacDonald)*, 1977
Lithograph
22 x 30

168. *The Lithographer*, 1978
Lithograph
22 x 30

169. *Seated Figure with Ascot*, 1979
Intaglio
9 x 10
Memorial Art Gallery of the
University of Rochester; Gift of
the Print Club of Rochester

• 170. *The Etcher Cassara*, 1980
Intaglio
19 ¾ x 23 ½
Collection of Dr. and
Mrs. Marshall Fagin
(Plate 37)

171. *Paul (Maguire)*, 1980
Lithograph
22 x 18

172. *Cartesian Composite*, 1981
Lithograph
22 x 30
Courtesy of the Poetry/Rare
Books Collection, University
Libraries, University at Buffalo,
the State University of New York

173. *Sinclair (Hitchings)*, 1981
Lithograph
22 x 15

174. *Barth, Fiedler, etc.*, 1982
Intaglio
12 ⅝ x 24 ½
Collection of Michael Morin,
Celtic Press

175. *Cartesian Interior*, 1982
Lithograph
27 x 20 ¼
Collection of Murray and
Barbara Brown

176. *Single Figure with Small
Monument*, 1982
Lithograph
18 ¼ x 13 ¼

177. *Edwin Dickinson*, 1983
Intaglio
10 x 11
Collection of Mitch Flynn and
Ellen Goldstein

• 178. *Double Beckett*, 1985
Lithograph
22 x 30
Collection of Frederic P. and
Alexandra B. Norton
(Plate 38)

• 179. *The Printer Morin*, 1986
Intaglio
22 ¼ x 23 ¾
Fine Arts Museums of San
Francisco, Gift of
Dr. Morton G. Rivo
(Plate 39)

180. *Michel Serres*, 1987
Lithograph
18 ½ x 23 ¼
Collection of Dr. and
Mrs. Joseph Fradin

181. *Krishna Reddy*, 1988
Intaglio
4 x 4

182. *Robert Duncan*, 1988
Intaglio
4 x 4

183. *Allen Ginsberg*, 1991
Intaglio
4 x 4

184. *Samuel Beckett*, 1991
Intaglio
4 x 4

185. *J. M. Coetzee*, 1992
Intaglio
4 x 4

186. *Robbe-Grillet*, 1992
Intaglio
4 x 4

187. *Study of Marcus Vincent*, 1994
Lithograph
24 ½ x 32

188. *Karel Appel*, 1995
Intaglio
4 x 4

189. *Michel Serres*, 1995
Intaglio
4 x 4

• 190. *The Sarajevan*, 1995
Intaglio
15 ¾ x 17
(Plate 40)

191. *Leslie Fiedler*, 1996
Intaglio
4 x 4

192. *Ray Federman*, 1996
Intaglio
4 x 4

193. *Jim Dine*, 1997
Intaglio
4 x 4

194. *John Ashbery*, 1997
Intaglio
4 x 4

195. *S.P.*, 1997
Intaglio
4 x 4

196. *Karel Berman*, 1998
Intaglio
10 ⅝ x 5 ⅞

197. *Thomas Insalaco*, 1998
Intaglio
8 x 5

198. *John Barth*, 1999
Intaglio
4 x 4

199. *Irving Feldman*, 1999
Intaglio
4 x 4

200. *The Scribe*, 1999
Engraving
6 diam.

201. *Younger Beckett*, 1999
Engraving
6 diam.

202. *Daniel Libeskind*, 2001
Intaglio
4 x 4

203. *Dine: In Catalunya*, 2001
Digital print
41 x 21 ¾

204. *Elie Wiesel II*, 2001
Engraving
6 diam.

205. *Federman: Broken Epitaph*,
2001
Digital print
40 ⅝ x 27 ¾

206. *Sigmund Abeles*, 2001
Engraving
6 diam.

207. *Herbert Hauptman*, 2002
Engraving
6 diam.

208. *Robert Pinsky*, 2002
Engraving
6 diam.

• 209. *Federman with Illuminations*,
2003
Lithograph
30 x 22 ¼
(Plate 41)

• 210. *Fiedler: Composite*, 2003
Digital Print
58 ¾ x 27 ¾
(Plate 42)

211. *Ginsberg Composite*, 2003
Digital print
58 ¾ x 27 ¾

212. *Levi Composite*, 2003
Digital print
58 ¾ x 27 ¾

BIOGRAPHY

BORN

1934 Pittsburgh, Pennsylvania

EDUCATION

1956 BFA, Carnegie Institute of Technology, now Carnegie Mellon

1960 MFA, Ohio University

SELECTED AWARDS

1962 Louis Comfort Tiffany Foundation Grant

1965 Netherlands Government Grant. Resident-Painter, Royal Academy, Amsterdam

1968 Museum of Fine Arts, Boston, Paul Sachs Memorial Award

 National Academy of Design, New York, Audubon Artists Prize

1972 CAPS Grant, New York State Council on the Arts

 3rd British International Print Biennale, Graphics Prize

1974 National Endowment for the Arts Fellowship (Printmaking)

 2nd Norwegian International Print Biennale, Graphics Prize

1980 American Academy/National Institute of Arts and Letters, Speicher-Hassam Fund Purchase Award

 National Endowment for the Arts Fellowship (Drawing)

1981 American Academy/National Institute of Arts and Letters, Speicher-Hassam Fund Purchase Award

1992 Virginia Center for the Creative Arts Fellowship

 Elected to National Academy of Design

1999 National Academy of Design 174th Annual Exhibition, 1st Benjamin Altman Figure Painting Prize

2001 National Academy of Design 175th Annual Exhibition, Adolph and Clara Obrig Prize in Painting

SELECTED SOLO EXHIBITIONS

1967 Albright-Knox Art Gallery, Members' Gallery, Buffalo, NY

 University of Maine Art Gallery, Orono

 Brandeis University, Waltham, MA

 Springfield College, MA

1968 Kalamazoo Institute of Arts, MI

1969 Illinois State University Art Gallery, Normal

1970 Schuman Gallery, Rochester, NY

 University of Illinois, Urbana-Champaign

 University of Oregon, Museum of Art, Eugene

1971 Canton Art Institute, OH

 Silverman Guild of Artists, New Canaan, CT

1972 Rodman Hall Arts Centre, St. Catharines, Ontario

 Jacob's Ladder Gallery, Washington, DC

 Imprint Gallery, San Francisco, CA

 Chautauqua Institution, NY

1973 University of Maine Art Gallery, Orono

 Middlebury College, Johnson Gallery, VT

1974 FAR Gallery, New York, NY

 More-Rubin Gallery, Inc., Buffalo, NY

 Impressions Gallery, Boston, MA

 Middle Tennessee State University Gallery, Murfreesboro

1975 Gadatsy Gallery, Toronto, Ontario

1976 Kalamazoo Institute of Arts, MI

 James Madison University, Art Gallery, VA

 Gadatsy Gallery, Toronto, Ontario

1977 Grand Rapids Art Museum, MI

 Hackley Art Museum, Muskegon, MI

 Nina Freudenheim Gallery, Buffalo, NY

1978 Gadatsy Gallery, Toronto, Ontario

 University of Michigan, Jean Paul Slusser Art Gallery, Ann Arbor

1979 FAR Gallery, New York, NY

1980 Nardin Galleries, New York, NY

 Gadatsy Gallery, Toronto, Ontario

1981 Art Gallery of Hamilton, Ontario

 Gadatsy Gallery, Toronto, Ontario

 University of New Hampshire Art Galleries, Durham

1983 Swain School of Design, Crapo Gallery, New Bedford, MA

1984 Gadatsy Gallery, Toronto, Ontario

 Buscaglia-Castellani Art Gallery, Niagara University, Niagara Falls, NY

 Chautauqua Institution, NY

1987 Gadatsy Gallery, Toronto, Ontario

 Miami University Art Museum, Oxford, OH

 Canton Art Institute, OH

1988 Memorial Art Gallery, Rochester, NY

 Wenniger Graphics Gallery, Boston, MA

1989 Albright-Knox Art Gallery, Members' Gallery, Buffalo, NY

 St. Lawrence University, Brush Art Gallery, Canton, NY

1990 Babcock Galleries, New York, NY

 Taller Galeria Fort, Cadaqués and Barcelona, Spain

 Hallwalls Contemporary Art Center, Buffalo, NY

 Milton Weil Gallery, 92nd Street Y, New York, NY

1991 Babcock Galleries, New York, NY

 Hollins University Art Gallery, Roanoke, VA

1993 Brigham Young University, Provo, UT

1994 Nina Freudenheim Gallery, Buffalo, NY

 Jamestown Community College Art Gallery, NY

1997 Kalamazoo Institute of Arts, MI

 Binghamton University Art Museum, NY

 Whittier College, Los Angeles, CA

 Yeshiva University Museum, New York, NY

 Milton Weil Gallery, 92nd Street Y, New York, NY

 Butler Institute of American Art, Youngstown, OH

1999 State University of New York, Chancellor's Gallery, Albany

2000 Gertrude Herbert Institute of Art, Augusta, GA

2001 Indiana University Art Gallery, Bloomington

2002 Ohio University Art Gallery, Athens

 Yeshiva University Museum, New York, NY

SELECTED GROUP EXHIBITIONS

1961 *Ohio Annual*, Columbus Gallery of Fine Arts, OH, First Drawing Prize

1962 *National Mid-Year Exhibition*, Butler Institute of American Art, Youngstown, OH, Third Painting Award

National Drawing Exhibition, Norfolk Museum of Art, VA, Purchase Award

National Exhibition, Chautauqua Institution, NY, Third Painting Award

Dayton Art Institute, OH

1963 *28th Biennial Exhibition of Contemporary American Painting*, Corcoran Gallery of Art, Washington, DC

National Drawing Exhibition, Ball State University Art Gallery, Munice, IN, Purchase Awards (two)

Pennsylvania Academy of the Fine Arts Biennial, Philadelphia

1964 *Kansas City Art Institute Invitational*, MO

14th National Print Biennial, Brooklyn Museum, NY

National Print Exhibition, Smithsonian Institution, Washington, DC, Pennell Fund Purchase Award

New York State Exposition, Syracuse, Grand Painting Prize

National Drawing Exhibition, Ball State University Art Gallery, Muncie, IN, Purchase Award

1965 *Painting Biennial*, Pennsylvania Academy of the Fine Arts, Philadelphia

American Drawings, University of Southern California, Los Angeles

National Drawing Exhibition, Bucknell University, Lewisburg, PA, Purchase Award

National Print Exhibition, University of North Dakota, Grand Forks, Purchase Award

National Print Exhibition, Wichita Art Association, KS, Purchase Award

National Print Exhibition, Springfield College, MA, Purchase Award

First New Talent Exhibition, Associated American Artists Galleries, New York, NY

Witte Memorial Museum, San Antonio, TX

1966 *Contemporary Drawings II*, Smithsonian Institution, Washington, DC
 Travels to: Los Angeles, Seattle, Nashville

Contemporary Drawings, I.B.M. Galleries, New York, NY

Contemporary American Drawings, University of Chicago, IL

Prints to Central America, U.S.I.A., Bogota, Colombia; San Salvador, El Salvador; San Jose, Costa Rica

1967 *Contemporary American Prints*, The Conference Center, Williamsburg, VA, Sponsored by the Print Council of America

American Printmakers, The White House, Washington, DC, Sponsored by the National Arts Foundation

International Invitational Exhibition, Philadelphia Print Club, PA

National Print Exhibition, Oklahoma Art Center, Oklahoma City, Purchase Award

National Print Exhibition, State University of New York College at Potsdam, Purchase Award

Group Exhibition—Gallery Artists, Tragos Gallery, Boston, MA

25 American Graphic Works Invitational, State University of New York College at Oneonta

Above the Pennsylvania Line-Drawing Invitational, Roberson Memorial Art Center, Binghamtom, NY

Boston Printmakers, Museum of Fine Arts Boston, MA

54th Annual Painting Exhibition, National Academy of Design, New York, NY

1968 *28 Amerikaanse Grafici*, Royal Academy of Fine Arts, Amsterdam, Holland

Audubon Artists Exhibition, National Academy of Design, New York, NY, Medal and Award

National Drawing Exhibition, Ball State University Art Gallery, Purchase Award

National Mid-Year Exhibition, Butler Institute of American Art, Youngstown, OH

Recent American Prints, University of Kentucky Art Gallery, Lexington, KY

International Print Exhibition, Manchester Institute of Art, NH, Purchase Award

Big Prints Invitational, State University of New York at Albany Art Gallery

Current Prints USA, Williams College Museum of Art, Williamstown, MA

1969 *Editions in Bronze, 6 Artists*, Associated American Artists Galleries, New York, NY and Marion Koogler McNay Art Institute, San Antonio, TX

Painting Biennial, Pennsylvania Academy of the Fine Arts, Philadelphia

American Drawings, Everson Museum, Syracuse, NY

1st Invitational Exhibition, San Diego Gallery of Fine Arts, CA

Inaugural Exhibition, Spanish International Pavilion Foundation, St. Louis, MO

National Print Exhibition, Library of Congress, Washington, DC, Pennell Fund Purchase Award

New York State Exhibition, Syracuse, NY, Munson-Williams-Proctor Institute Purchase Award

Drawing Invitational Exhibition, Illinois State University, Normal, Purchase Award

1970 *2nd British International Print Biennial*, Bradford City Art Museum, England

International Print Exhibition, Seattle Art Museum, WA

Mainstreams '70 International Painting Exhibition, Hermann Fine Arts Center, Marietta College, OH, Third Award of Distinction

New Editions '70, University of Hartford Joseloff Gallery, CT

Six Young Artists, Fendrick Gallery, Washington, DC

National Print Exhibition, Bradley University Art Gallery, Peoria, IL

1971 *35 Years in Retrospect*, Butler Institute of American Art, Youngstown, OH

Contemporary Graphics: Recent Acquisitions, Albright-Knox Art Gallery, Buffalo, NY

Drawing-USA-71, Minnesota Museum of Art, St. Paul, Purchase Award

4th Invitational Miniature Print Exhibition, Pratt Graphic Center, New York, NY

National Exhibition, Chautauqua Institution, NY, First Painting Award

National Print Exhibition, Texas Tech University Art Gallery, Lubbock

Loan Exhibit from the Collection of Dr. and Mrs. Jacob Weinstein, Washington and Lee University, Lexington, VA

National Print and Drawing Exhibition, Western Illinois University, Macomb, Purchase Award

National Print Exhibition, Library of Congress, Washington, DC

1972 *3rd British International Print Biennial*, Bradford City Art Museum, England, Purchase Award
 Travels in 1972–73 to: DLI Museum and Arts Centre, Durham; Whitechapel Art Gallery, London; University of East Anglia, Norfolk; Kettle's Yard Gallery, Cambridge, England; Newport Museum and Art Gallery, Wales

Painting Invitational: The Outdoors, FAR Gallery, New York, NY

Cultural Exchange Exhibition: Selected Buffalo Artists, Kanazawa Art Museum, Kanazawa, Japan

Humor in Prints, Associated American Artists Galleries, New York, NY

American Printmakers, Rose Art Museum, Brandeis University, Waltham, MA

1st National Print and Drawing Exhibition, Davidson College, NC

2nd Invitational Exhibition, San Diego Gallery of Fine Arts, CA

1973 *Contemporary American Graphics*, Pushkin Museum, Moscow and Leningrad, Russia

25 Amerikanske Grafikere, Oslo, Moss, Drammen, Norway

4th National Painting Invitational, Doane College, Crete, NE Purchase Award

Six Artists Revisited, Kalamazoo Institute of Art, MI

Lincoln First Collection–Upstate New York, Lincoln First Square, Rochester, NY

10 Figurative Artists Invitational, State University of New York at Brockport

The American Landscape, FAR Gallery, New York, NY

Nine Western New York Artists— C.A.P.S. Grantees, Charles Burchfield Center, Buffalo, NY

Printmaking Now Invitational, West Texas State Museum, Lubbock

1974 *2nd Norwegian International Print Biennale*, Fredrikstad, Norway, Graphics Award

Breverman, Orr, Piper, Museum of Modern Art, Oxford, England

Multiplemedia, Erie Art Museum, PA, Purchase Award

Contemporary American Realism, FAR Gallery, New York, NY

Drawings by Seven Artists, Albright-Knox Art Gallery, Buffalo, NY

Works by Living American Artists— National Endowment Purchase, Charles Burchfield Center, Buffalo, NY

Drawings and Prints: National Exhibition, Mt. Holyoke Museum of Art, North Hadley, MA

40th Anniversary Exhibition, Associated American Artists Galleries, New York, NY

1st National Drawing Exhibition, Rutgers University Art Gallery, Camden, NJ, Purchase Award

2nd Miami Graphics Biennial, Metropolitan Art Center, FL

1st National Print and Drawing Competition, University of Colorado, Henderson Museum, Boulder, Purchase Awards (two)

1975 *3rd International Graphics Biennial*, Honolulu Academy of Arts, HI

8 Figurative Artists, University of North Dakota Art Gallery, Grand Forks

Picnic: Invitational Exhibition, Country Art Gallery, Locust Valley, NY

1976 *Paintings for the Embassies*, The Department of State, US Embassies in Belgrade and Caracas

200 Years of American Works on Paper, FAR Gallery, New York, NY

Drawings in Contrast, Gadasty Gallery, Toronto, Ontario

American Drawings 1976, Portsmouth Art Center, Portsmouth, VA, Purchase Award

16 Contemporary Printmakers Invitational, Lake Placid School of Art, NY

20 Printmakers and Their Students, Southern Connecticut State College Art Gallery, New Haven

National Drawing Exhibition, Ball State University Art Gallery, Muncie, IN, Purchase Award

24 American Printmakers Invitational, University of Hawaii and State Arts Council, Hilo

Charles Penney Bequest, Memorial Art Gallery, Rochester, NY

Recent Editions from Impressions Workshop, Philadelphia Print Club, PA

Works on Paper, Michael Rockefeller Arts Center, State University of New York College at Fredonia

Colorprint USA, Texas Tech University, Lubbock

1977 *Art 8 '77*, International Kunstmesse, Basel, Switzerland

Begegnung mit Buffalo, Auslands Institut, Dortmund, West Germany

Selected Drawings from Canadian Museum Collections, Rodman Hall Arts Centre, St. Catharines, Ontario

Drawings by Fourteen Artists, Emporia State University Art Gallery, KS, Purchase Award

In Western New York: Invitational Biennial, Albright-Knox Art Gallery, Buffalo, NY

A Tribute to Edwin Dickinson, Charles Burchfield Center, Buffalo, NY Travels to: Herbert F. Johnson Museum of Art, Cornell University, Ithaca, NY; and Albany Institute of History and Art, NY

Breverman, Blackwood, Levine, Soyer, Urquhart, City Hall, Toronto, Ontario

Boston Printmakers Exhibition, DeCordova Museum, Boston, MA

1978 *Arte Fiera di Bologna '78*, Bologna, Italy

Gallery Artists Group Exhibition, FAR Gallery, New York, NY

Two by Twenty, Kalamazoo Institute of Arts, MI

Invitational Exhibition, Huber Gallery, Washington, DC

Boston Printmakers 30th National Exhibition, Boston Arts Complex, MA, Ture Bengtz Memorial Purchase Award

1979 *Feast the Eyes*, Art Gallery of Ontario, Toronto

Works on Paper: Recent Acquisitions, Albright-Knox Art Gallery, Buffalo, NY

P.S.1, Institute of Art and Urban Resources, Long Island City, NY

Different Aspects of Realism, Gadatsy Gallery, Toronto, Ontario

National Print and Drawing Exhibition, University of South Dakota, Vermillion

2nd Invitational Contemporary Drawing Exhibition, Fine Arts Gallery, Lake Placid Center for Music, Drama, and Art, NY

10 Artists: Drawing Invitational, Lee Hall Gallery, Northern Michigan University, Marquette

Paintings for the Embassies, US Department of State, Caracas, Venezuela

Images Through Drawings, Rodman Hall Arts Center, St. Catharines, Ontario

1980 *Small Works*, New York University, New York, NY

Five Americans, Rodman Hall Arts Centre, St. Catharines, Ontario

Drawings: Abeles, Albert, Breverman, Bultman, Landau, Nardin Galleries, New York, NY

Hassam Fund Purchase Exhibition, American Academy/National Institute of Arts and Letters, New York, NY

57th Annual Exhibition, Newport Art Association, RI

Art and the Law, '80, Minnesota Museum of Art, National Exhibition, St. Paul Travels to: Tulane University, New Orleans, LA; City Hall, Dallas, TX; State Bar Association, Omaha, NB; Austin, TX; St. Louis, MO; Raleigh, NC

70 Prints: Masterpieces Spanning Five Centuries, University of Maine Art Gallery, Orono

Boston Printmakers 32nd National Print Exhibition, DeCordova Museum, Lincoln, MA, Cabot Corporation Purchase Award

1981 *The Human Form: Interpretations*, Meyerhoff Gallery Dedication Exhibition, Maryland Institute, Baltimore

CAPS at the State Museum, New York State Museum, Albany

Apokalypsis, Nardin Galleries, New York, NY

National Works on Paper Invitational Exhibition, Griffith Gallery, Austin State University, TX

In Western New York: Invitational Biennial, Albright-Knox Art Gallery, Buffalo, NY

Boston Printmakers 33rd National Exhibition, Boston Center for the Arts, MA
Travels to: Fitchburg Art Museum, MA

The New York Landscape, State University Plaza Art Gallery, Albany

25th National Print Exhibition, Hunterdon Art Center, Clinton, NJ
Travels to: Allentown Art Museum, PA

Hassam Fund Purchase Exhibition, American Academy/National Institute of Arts and Letters, New York, NY

Art and the Law, '81, Minnesota Museum of Art, St. Paul
Travels to: Tallahassee, FL; Raleigh, NC; Cedar Rapids, IA; Cincinnati, OH; Dallas, TX

Art Toronto '81, International Art Fair, Harbourfront Art Gallery, Toronto, Ontario

CAPS at F.I.T., Fashion Institute of Technology Galleries, New York, NY

1982 *Jewish Themes/Contemporary American Artists*, The Jewish Museum, New York, NY

Society of American Graphic Artists 59th National Exhibition, The Cooper Union School of Art and Architecture Galleries, New York, NY, Judith Leiber Purchase Award

Art and the Law, '82, Minnesota Museum of Art Landmark Center, St. Paul

Travels to: Supreme Court Building, Tallahassee, FL; Court of Appeals, Corpus Christi, TX; University of Colorado, Boulder

1983 *The New York Landscape*, Pratt Manhattan Center Galleries, New York, NY

Boston Printmakers Invitational, Art Museum, Duxbury, MA

Contemporary Realism, Joanna Dean Galleries, New York, NY

Masks, West Virginia University Museum, Morgantown

Boston Printmakers 35th National Exhibition, Boston University Art Gallery, MA, Purchase Award

1984 *Inaugural Gala Exhibition*, Associated American Artists Galleries, New York, NY

Heads and Portraits: Part 2— Discovering the Permanent Collection (Breverman, Bonnard, Epstein, Matisse, Town and Tamayo), Rodman Hall Arts Centre, St. Catharines, Ontario

Miami Collects, Miami University Art Museum, Oxford, OH

Boston Printmakers 36th National Exhibition, Brockton Art Museum, MA

Canadian and International Works on Paper, Rodman Hall Arts Centre, St. Catharines, Ontario

Gallery Artists Drawing Exhibition, Gadatsy Gallery, Toronto, Ontario

Selections from the Jewish Museum of New York Collection, Jewish Theological Seminary of America, New York, NY

1985 *Boston Printmakers 27th National Exhibition*, Rose Art Museum, Brandeis University, Waltham, MA

Self-Portraits and More: the Pierson Collection, Flint Institute of Arts, MI

Society of American Graphic Artists 61st National Exhibition, Nassau Community College Gallery, Garden City, NY, Goldstein Foundation Purchase Award to New York Public Library Collection

National Printmakers Invitational, University of Hawaii, Hilo

Printmakers '85: Tallahassee Invitational, University of Florida Art Gallery
Travels to: Florida State University Fine Arts Gallery, Gainesville

Works By Americans, Art Gallery of Hamilton, Ontario

Print Invitational, DePree Art Center Gallery, Hope College, Holland, MI

Portraits: Artists By Artists, Montserrat College of Visual Arts, Beverly, MA

A Toast to the NEA: Works by Western New York Artists, Burchfield Art Center, Buffalo, NY

Art and the Law, '85, National Invitational Exhibition
Travels to: Russell Senate Office Building, Washington, DC; Cedar Rapids Museum of Art, IA; Salt Lake Art Center, UT; Minnesota Museum of Art, St. Paul; Albuquerque Museum, NM

7th National Print Exhibition, Honolulu Academy of Arts, HI

Group Exhibition: New Artists, Merida-Rapp Graphics Gallery, Louisville, KY

Drawing Invitational: 12 Artists, Elzay Gallery, Ohio Northern University, Ada

An Affair of the Heart, Albright-Knox Art Gallery, Buffalo, NY

1986 *Drawings*, Roger Ramsay Gallery, Chicago, IL

Works of the Figure: 11 Contemporary Approaches, Allegheny College Galleries, Meadville, PA

Commitment to Vision, University of Oregon Museum of Art, Eugene

Prints Invitational, Virginia Museum of Fine Arts, Richmond

Drawings, Nina Freudenheim Gallery, Buffalo, NY

Society of American Graphic Artist 62nd Annual, Lever House Galleries, New York, NY, Graphic Chemical & Ink Company Purchase Award

25th Anniversary Exhibition, Oxford Gallery, Rochester, NY

1987 *Ten Years of Small Paintings, Drawings and Prints 1975-85: Selections from the Kansas National*, Emporia State University Art Gallery, KS

Portsmouth Collects, Portsmouth Museum, VA

Drawing Invitational: Six Artists, Clara Eagle Gallery, Murray State University, KY

30th Prints and Drawings Annual, University of North Dakota Museum of Art, Grand Forks, Purchase Award

Survey of Contemporary American Printmaking, Kutztown University Art Gallery, PA

Sacred Arts: A Living Tradition, Ohio State University, Columbus

Recent Acquisitions, Canton Art Institute, OH

Portraits in Prints, Trisolini Gallery, Ohio University, Athens

Contemporary American Drawings, Wichita Art Museum, KS

63rd International Exhibition, Philadelphia Print Club, PA, Print Club Selection Award and Patron Award

Artists Who Teach, Federal Reserve Board Art Gallery, Washington, DC

Harvard University Carpenter Center for Visual Arts, MA

The Wayward Muse: Historical Survey of Painting in Buffalo, Albright-Knox Art Gallery, Buffalo, NY

1988 *Intimate Gestures Realized Visions: Masterworks on Paper*, Albright-Knox Art Gallery, Buffalo, NY

Recent Prints, Boston Public Library Print Department, MA

International Prints and Drawings from the Norton Collection, Kitchener-Waterloo Art Gallery and Rodman Hall Arts Centre, St. Catharines, Ontario

The American Miniature Printmaker, San Diego State University Masters Gallery, CA, Purchase Award
 Travels to: India and the Far East

Contemporary American Drawings, Kansas Art Commission Traveling Exhibition, sponsored by Wichita Art Museum

8th Mini-Print Internacional, Cadaqués and Barcelona-Taller Galeria Fort, Spain
 Travels to: Capilla del Antiquo Hospital de la Santa Cruz in collaboration with the Barcelona Council; Manaru Gallery, Seoul; Foundation Colliouré, Châteaux Royale, Collioure; Galerie des Editions Universelles, Toulouse

Gallery Group Exhibition, Zohar Gallery, Toronto, Ontario

Diamonds are Forever: Artists & Writers on Baseball, New York State Museum, Albany
 Travels in 1987–90 to: Norton Gallery of Art, Palm Beach, FL; Museum of Art, San Juan, Puerto Rico; Contemporary Arts Center, Cincinnati, OH; Utah Museum of Fine Arts, Salt Lake City; Museum of Fine Arts, Houston, TX; Baltimore Museum of Art, MD; Chicago Public Library and Cultural Center, IL; Oakland Museum, CA; New York Public Library, NY

1989 *Past and Present: American Art from the Gallery's Collection*, Babcock Galleries, New York, NY

Drawings of the Human Head, Emmanuel Gallery, Metropolitan State College, Denver, CO

9th Mini-Print Internacional, Taller Galeria Fort Cadqués and Galeria Lassaletta, Barcelona, Spain

Travels to: Museo Nacional de la Stampa, Mexico City; Festival Internacional de Teatro, Manizales, Colombia; Sala del Silencio, Comune de Bologna, Italy

American Print Survey, Furlong Gallery, University of Wisconsin-Stout

The Art Show—Benefit for the Henry Street Settlement, 7th Regiment Armory, New York, NY

Contemporary Prints, Cannon Beach Gallery, OR

4th International Biennial Print Exhibition: ROC 1989, Taipei Fine Arts Museum, Taiwan

Collaborations, Center of Contemporary Art, Miami, FL

National Small Print Exhibition, University of Wisconsin–Parkside

Methods in Art History: Highlights from the Permanent Collection, University of New Hampshire Art Galleries, Durham

33rd National Print Exhibition, Hunterdon Art Center, Clinton, NJ
 Travels to: The Newark Library, NJ; The Monmouth Museum, Lincroft, NJ; William Paterson College, Ben Shahn Gallery, Wayne, NJ

Society of American Graphic Artists 63rd National Exhibition, Federal Plaza, New York, NY

14th Annual National Invitational Drawing Exhibit, Norman Eppink Art Gallery, Emporia State University, KS

1990 *10th Mini-Print Internacional*, Taller Galeria Fort, Cadaqués, Spain
 Travels to: FIAC SAGA '90, Grand Palais, Paris, France; Museu d'Art de Sabadell, Barcelona; Museu del Suro, Palafrugell; Girona Serveis Territorials, Tortosa, Tarragona, Spain. In Japan: Osaka, Fukuoka, Kochi, Tokyo, Sapporo, Hakodate, Tomakomai, and Kushiro

National Invitational Drawing Exhibition, Exhibits USA.
 Travels to: Albrecht-Kemper Art Museum, St. Joseph, MO; Baylor University, Waco, TX ; Kansas State University

34th National Print Exhibition, Hunterdon Art Center, Clinton, NJ.
 Travels to: Payne Gallery, Moravian College, Bethlehem, PA

SUNY Art Now '90: Breverman, DeMauro, Henderson, Sokolowski, New Visions Gallery, Ithaca, NY

1991 *11th Mini-Print Internacional*, Taller Galeria Fort, Cadaqués and Galeria M. Salvat, Barcelona, Spain

Diamonds are Forever: Artists & Writers on Baseball, Yurakucho Art Forum, Tokyo, Japan; Denver Art Museum, CO; La Jolla Museum of Contemporary Art, CA; Taipei Fine Arts Museum, Taiwan; Skydome, Toronto, Ontario; Scottsdale Center for the Arts, AZ; Albright-Knox Art Gallery, Buffalo, NY

Art about Art, Springfield Art Museum, MO

Society of American Graphic Artists (NYC) Lynd Ward Traveling Exhibition, McDermott, Will and Ellery Galleries, New York, NY

The Lithographic Process, University Art Center, Arkansas State University, Jonesboro

43rd North American Print Exhibition, DeCordova Museum and Sculpture Park, Lincoln, MA

5th National Print Exhibition, Communications Arts Gallery, University of Wisconsin–Parkside

Society of American Graphic Artists 64th National Exhibition, Lever House Gallery, New York, NY

Portraits and Heads: Selections from the Burk Collection, University of New Hampshire Art Galleries, Durham

Celebrating 20 Years: 1971–1991, Fox Graphics Ltd., Merrimac, MA

1992 *Personal Myth/Historical Memory: Breverman, Cohen, Kedem*, Philadelphia Museum of Judaica, PA

Drawing on Experience, Miami University Art Museum, Oxford, OH

Gallery Group, Babcock Galleries, New York, NY

12th Mini-Print Internacional, Taller Galeria Fort, Cadaqués, Spain; and Wingfield Art and Music Festival, England

Drawing Invitational, Middle Tennessee State University Art Gallery, Murfreesboro

The Figure: Breverman, Bumbeck, Patterson, Wenniger Graphics Gallery, Boston, MA

Drawings from the Emporia State University Collection, Brigham Young University Art Gallery, Provo, UT

Collections Update: 1992 Acquisitions, National Academy of Design, New York, NY

1993 *Paintings from the Permanent Collection*, Butler Institute of American Art, Youngstown, OH

65th Society of American Graphic Artists National Exhibition, Federal Plaza Galleries, New York, NY

Charles Rand Penney Collection of Western New York Art, Burchfield Art Center, Buffalo, NY

Audubon Artists 51st National Exhibition, National Arts Club, New York, NY, Gold Medal of Honor and Prize

168th National Exhibition, National Academy of Design, New York, NY, Ralph Fabri Prize

Great American Art Auction Invitational, Butler Institute of American Art, Youngstown, OH

1994 *International Print Triennial,*
Cracow '94, Palac Sztuki
 Travels to: Nuremberg, Germany

Peter Harris Memorial Exhibition,
Rodman Hall Arts Centre,
St. Catharines, Ontario

169th Annual National Exhibition,
Invited Section, National Academy of
Design, New York, NY

8th National Print Exhibition, University
of Wisconsin-Parkside

*A Symposium of the Imagination:
Robert Duncan in Word and Image,*
University at Buffalo, Poetry and Rare
Books Collection, NY; University of
Minnesota, Twin Cities; and
Mills College Art Gallery, Oakland, CA

Drawing Together, Nina Freudenheim
Gallery, Buffalo, NY

14th Mini-Print Internacional, Taller
Galeria Fort, Cadaqués, Spain

Curs Internacional de Arquitecture,
Barcelona, Spain

1995 *15th Mini-Print Internacional,*
Barcelona and Cadaqués, Taller
Galeria Fort, Spain
 Travels to: Joensuun Aaidemuseu,
 Finland; and L'Etang d'Art, Bages,
 France

*Consumenta '95 International Print
Triennial,* Nuremburg, Germany

The World of Ex-Libris, Museum of
Applied Arts, Belgrade, Serbia
 Travels in 1996–1997 to: Museo de
 Belles Artes, Buenos Aires,
 Argentina; London, England;
 Lausanne, France; Ljubljana,
 Slovenia; Rome, Italy

Recent Award Winners Invitational,
Lever House Galleries, New York, NY

170th Annual National Exhibition,
National Academy of Design, New
York, NY, Leo Meissner Prize

1996 *XIII Premio Internazionale Biella per
l'Incisione,* Palazzo della Regione,
Biella, Italy
 Travels in 1997 to: Ravenna,
 Alessandria, and Torino, Italy

10th National Small Print Exhibition,
Purdue University Art Galleries, West
Lafayette, IN

*Audubon Artists 54th Annual
Exhibition,* Federal Hall, New York, NY,
American Artist Award

Delta National Small Prints Exhibition,
Arkansas State University, Fine Arts
Center Gallery, Jonesboro,
Purchase Award

1997 *International Print Exhibition,* Portland
Art Museum, OR

Winter Light, Bermuda National
Gallery, Hamilton

17th Print Internacional, Cadaqués
and Barcelona, Spain

*Realm Between Realms/Histories
Between Histories,* National Jewish
Museum, Washington, DC

Landscapes—Nature, National
Academy of Design, New York, NY

*A Passion for Prints: The Norton
Family Collection,* Albright-Knox Art
Gallery, Buffalo, NY

Drawings Invitational,
Tatistcheff Gallery, New York, NY

International Print Triennial '97,
Cracow, Poland and Nuremberg,
Germany

*19th International Independante
Exhibition of Prints,* Kanazawa
Prefectural Gallery, Yokohama, Japan

*9th International Print Biennial —Varna
'97,* Varna, Bulgaria

1998 *1st Beijing International Exlibris
Exhibition,* Bejing, People's Republic
of China

*About Memory: A Selection of 20th
Century Portraits,* Ball State
University Museum, Muncie, IN

Impressions of Brittany, French
Embassy, Washington, DC

*Invitational Benefit Auction
(Sothebys),* Butler Institute of
American Art, Youngstown, OH

173rd National, National Academy of
Design, New York, NY

156th National, Audubon Artists, Inc.,
Salamagundi Club, New York, NY

1999 *Exlibris Prints,* Museo Civico Di
Grafica, Brunico, Italy

International Small Engraving Salon,
Florean Museum, Carbunari, Romania

19th Mini-Print Internacional, Taller
Galeria Fort, Cadaqués and Barcelona,
Spain

*12th Deutsche International Grafik
Triennale,* Frechen, Germany

Biennale de Dessin, Château du
Puget, Alzonne, France

International Print Triennale, Museu
de Arte Moderna, Rio de Janiero,
Brazil

*Allen Ginsberg and Friends: Including
Property from the Estates of Allen
Ginsberg, Jack Kerouac and
William S. Burroughs,* Sothebys,
New York, NY

Black and White, Boston Printmakers,
Federal Reserve Bank, MA

*Drawings from Boston: 100 Drawings
by 50 Living Artists with Ties to
Boston,* Boston Public Library, Wiggin
Gallery, MA

2000 *175th National,* National Academy of
Design, New York

*3rd Egyptian International Print
Triennale,* National Centre of Fine
Arts, Giza

*1st Mini-Print International—Vitoria
2000,* Museum of Art of Espirito
Santo, Vitoria City, Brazil

*4th British International Miniature Print
Exhibition,* Bankside Gallery, London;
The City Art Gallery, Leicester; and

Bristol City Museum and Art Gallery,
England

International Print Triennale, Palac
Sztuki, Cracow and Contemporary Art
Gallery, Katowice, Poland

Qingdao International Print Biennial,
Qingdao Cultural Bureau Art Gallery,
People's Republic of China

*Rembrandt to Rauschenberg: The
Norton Print Collection,* Albright-
Knox Art Gallery, Buffalo, NY

*Torment, Terror, Tragedy and the
Struggle to Survive,* Baker University,
Holt-Russell Gallery, Baldwin City, KS

*68th National Exhibition, Society of
American Graphic Artists,* Stephan
Gang Gallery, New York, NY

2001 *4th International Print Triennial,* Lahti
Art Museum, Finland

Impressions of Brittany, Institute
Française, New York, NY

Fables of Jean de la Fontaine, Center
for Advanced Art and Culture,
Institute of American Universities,
Aix-en-Provence, France.
 Travels to: Temple Gallery,
 Rome, Italy

Contemporary Prints, Metropolitan
Museum of Art Mezzanine Gallery,
New York, NY

*Selections from the Permanent
Collection,* Bermuda National Gallery,
Hamilton

2002 *18th International Exhibition of Modern
Exlibris—Malbork 2002,* Malbork
Museum, Poland

22nd Print Internacional, Taller Galeria
Fort, Cadaqués and Barcelona, Spain

4th International Engraving Salon,
Florean Museum, Maramures,
Romania

*2002 Pacific States Biennial National
Print Exhibition,* University of Hawaii,
Hilo, Purchase Award

69th National Exhibition, Society of American Graphic Artists, Grand Gallery, Art Students League of New York, NY, Renaissance Graphic Arts, Inc. Award

Prints: 15 Artists, Denise Bibro Fine Art, New York, NY

Zeichen der Gegenwart, Vienna Art Center Gallery, Austria

2003 *Me, Myself and I: Self-Portraits*, Indianapolis Museum of Art, IN

Pulp Fiction/Works on Paper, French Library and Cultural Center, Boston, MA

Prints, Flint Institute of Arts, MI

Works from Pont Aven, L'Espace Melanie, Riec-sur-Belon, Brittany and Mona Bismark Foundation, Paris, France

Mostra Internazionale di Exlibris, Museo Civico di Brunico, Provincia Autonoma di Bolzano, Italy

5th International Small Engraving Salon, Florean Museum, Maramures, Romania

International Print and Drawing Exhibition: In Celebration of Silpakorn University's 60th Anniversary, Art and Culture Centre, Bangkok, Thailand

5th British International Print Exhibition, Gracefield Arts Centre, Dumfries, Scotland, and tour of the UK in 2004

61st Annual Exhibition, Audubon Artists Inc., Salamagundi Club, New York, NY

25th Anniversary Invitational Exhibition, Purdue University, Robert L. Ringel Gallery, West Lafayette, IN

Revealing the Vaults: Posturing, Rodman Hall Arts Centre, Brock University, St. Catharines, Ontario

2004 *4th International Triennial of Graphic Art*, Ministry of Culture of the Republic of Bulgaria, Sofia

Small Works, University of Alberta Print Centre, Edmonton

Society of American Graphic Artists 70th National Exhibition, Susan Teller Gallery, New York, NY

Images of War, Burchfield-Penney Art Center, Buffalo, NY

Selections from the Permanent Collection, Dowd Fine Arts Center Gallery, State University of New York College at Cortland

Realism Now: Traditions & Departures —Mentors and Protégés, Vose Galleries, Boston, MA

SELECTED COLLECTIONS

Albright-Knox Art Gallery, Buffalo, NY

American Embassy Collections: Bogota, San Jose, and El Salvador

Arizona State University, Tempe

Art Gallery of Hamilton, Ontario

Art Gallery of Windsor, Ontario

Ball State University Art Museum, Muncie, IN

Baltimore Museum of Art, MD

Bermuda National Trust, Masterworks Heritage Fund, Hamilton

Boston Public Library Print Collection, MA

Bowdoin College, Museum of Art, Brunswick, ME

Bradford City Art Museum, England

Brigham Young University, Provo, UT

The British Museum, London, England

Burchfield-Penney Art Center, Buffalo, NY

Bucknell University, Lewisburg, PA

Bulgaria Art Foundation, Varna

Butler Institute of American Art, Youngstown, OH

Canton Art Institute, Ohio

Chrysler Art Museum, Norfolk, VA

Cleveland Museum of Art, OH

The College of William and Mary, Muscarelle Museum of Art, Williamsburg, VA

Columbia University, New York, NY

Crestwood Paper Company, New York, NY

Dayton Art Institute, Dayton, OH

DeCordova Museum and Sculpture Park, Lincoln, MA

Emporia State University, KS

Equitable Life Insurance Company, New York, NY

Everson Museum, Syracuse, NY

Fine Arts Museums of San Francisco, CA

First National City Bank of Chicago, IL

Flint Institute of the Arts, MI

Florida State University, Tallahassee, FL

Globe Industrial Bank, Boulder, CO

Graphic Controls Corporation, Buffalo, NY

Hamline University Art Galleries, St. Paul, MN

Honolulu Academy of Arts, HI

Houdaille Industries, Inc., Ft. Lauderdale, FL

Illinois State University, Normal, IL

Indianapolis Museum of Art, IN

Israel Museum, Jerusalem

Jennison Associates Capital Corporation, Boston, MA

The Jewish Museum, New York, NY

Kalamazoo Institute of Arts, MI

Kennedy Museum of Art, Ohio University, Athens, OH

Library of Congress, Washington, DC

Lincoln First Collection, Rochester, NY

Lynnwood Arts Centre, Simcoe, Ontario

Madison Art Center, WI

Manchester Institute of Art, NH

Manufacturers and Traders Trust Co., Buffalo, NY

Memorial Art Gallery of the University of Rochester, NY

Metropolitan Museum of Art, New York, NY

Miami University Art Museum, Oxford, OH

Michigan State University, Kresge Art Gallery, East Lansing, MI

Middle Tennessee State University, Murfreesboro

Milwaukee Art Museum, WS

Minnesota Museum of Art, St. Paul

Munson-Williams-Proctor Institute, Utica, NY

The Museum of Modern Art, New York, NY

Museo Civico di Grafica, Brunico, Italy

Muskegon Art Museum, WI

National Academy of Design, New York, NY

The National Portrait Gallery, Washington, DC

Newark Public Library, NJ

New York Public Library Print Collection, NY

Oklahoma Art Center, OH

Pennsylvania State University Museum of Art, State College

Philadelphia Museum of Art, PA

Portland Art Museum, OR

Portsmouth Museum of Fine Arts Commission, VA

Princeton University Art Museum, NJ

Purdue University Galleries, West Lafayette, IN

Pushkin Museum, Moscow, Russia

Qingdao Art Gallery, People's Republic of China

Randolph-Macon Woman's College, Maier Museum of Art, Lynchburg, VA

Rich Products Corporation, Buffalo, NY

Ringling Museum of Art, Sarasota, FL

Rodman Hall Arts Centre, Brock University, St. Catharines, Ontario

Rutgers University Art Gallery, Camden, NJ

Rutgers University, Zimmerli Art Museum, New Brunswick, NJ

Smith College Museum of Art, Northhampton, MA

Smithsonian Museum of American Art, Washington, DC

Springfield Museum of Fine Arts, MA

University of California, Grunewald Center for the Graphic Arts, Los Angeles

University at Buffalo Foundation

University of Colorado, Boulder

University of Georgia, Athens

University of Iowa, Iowa City

University of Maine, Orono

University of Maryland Museum of Art, College Park

University of Minnesota, Twin Cities, Frederick R. Wiseman Art Museum, St. Paul

University of Nebraska, Sheldon Memorial Art Gallery, Lincoln

University of North Carolina, Ackland Art Center, Chapel Hill

University of North Dakota, Grand Forks

University of Oklahoma Museum of Art, Norman

University of Oregon Museum of Art, Eugene

University of Virginia, Bagly Memorial Museum, Charlottesville

University of West Virginia, Morgantown

University of Wisconsin–Parkside

Utah Museum of Art, Salt Lake City

Victoria and Albert Museum, London, England

Wichita Art Museum, KS

Whitney Museum of American Art, New York, NY

Yeshiva University Museum, New York, NY

PRINT SHOP AND MASTER PRINTER COLLABORATIONS

1965–66 Atelier Piet Clement, Amsterdam. Four etchings editioned with master printer Piet Clement.

1970–87 Impressions Workshop, Boston (later Paul Maguire, Inc. then Flatrock Press, Inc.) Invited by Dr. Stephen Andrus, owner, and Robert Marx, workshop artistic director, to create a series of etchings and lithographs. Worked with master printer Herb Fox (Tamarind-trained), Paul Maguire, John Hutcheson, Robert Townsend, Carol Luick, and Jennifer Hilton. Many color editions produced.

1970 George C. Miller & Son, New York. One lithograph printed by master printer Burr Miller. Arrangement made by Associated American Artists Gallery.

1970–71 Ohio University Lithography Workshop, Athens. Two lithographs printed by master printer Donald Roberts (Tamarind-trained).

1974 & 76 Lake Placid School of Music, Drama, and Art, Lake Placid, NY. Two screenprint editions and one color lithograph edition printed by artists, James Catalano and Martin Anderson.

1974–77 Kalamazoo Institute of Art Lithography Workshop, MI. Three lithograph editions printed by Rita Messenger-Delbert and Hanne Greaver.

1974–78 Lakeside Studio, Lakeside, MI. Several color lithograph editions printed by Jonathan Clemens, Donald Herbert and master printer Jack Lemon (Tamarind-trained). Lemon printed one edition at his Landfall Press, Chicago.

1977–79 Fox Graphics Editions, Ltd., Boston. Several color lithographs editioned with master printer Herb Fox.

1978–80 University of Michigan Printmaking Studio, Ann Arbor. One lithograph and one etching edition completed. Printed by Frank Cassara, Mike Crouse and Paul Martyka, assisted by Bill Barr.

1980 Ohio Northern University Printshop, Ada. One lithograph edition printed by Tom Gordon.

1980–82 West Virginia University and Celtic Press. Three etchings editioned by Michael Morin and Curt Labitzke.

1987 Mulberry Press, Boston. One woodcut edition printed by master printer Michael Berdan.

1990 Taller Galeria Fort, Cadaqués, Spain. Artist created two etchings, never editioned.

1993–94 Brigham Young University Print Studies Workshop, Provo. One color lithograph editioned by master printer Todd Frye (Tamarind-trained).

2001–02 Ohio University School of Art Printmaking Department. One five-color lithograph editioned by James Leger, Benjy Davies and Pat Hunsinger.

BIBLIOGRAPHY

PERIODICALS

Ahlander, Leslie Judd. "Corcoran Biennial Has New Look." *Washington Post*, 20 January 1963, G9.

Albright, Thomas. "Breverman: Imprint Gallery." *San Francisco Examiner and Chronicle*, October 1972.

"Amerikansk Grafikk." *Det Norske Arbeiderparti* (Oslo), April 1973 (illus.).

"Amerikansk i Moss." *Kunst I Daq* (Norway), 16 April 1973 (illus.).

Andrews, Arthur T. "Breverman: More Than Glances." *Springfield (Mass.) Republican*, 1967.

Bannon, Anthony. "Interview with Painter Harvey Breverman." *Buffalo Evening News*, Gusto Section, 16 September 1977, 27 (illus.).

———. "Breverman Art Multi-leveled." *Buffalo Evening News*, Gusto Section, 21 September 1977 (illus.).

———. "Breverman, Drisch Open Windows to Distinctive Light." *Buffalo News*, 8 May 1984, C7.

Baumgardner, George. "Review: The Outer Limits Explored at New Visions Group Show." *Ithaca Journal*, 22 February 1990 (illus.).

"Breverman Coming to Augusta." *The Metro Augusta*, 1 August 2000, 33.

"Breverman, Orr, Piper at the Museum of Modern Art." *Museum of Modern Art Bulletin* (Oxford, England), June 1974.

"Breverman, Tate on Display." *North Canton (OH) Journal*, 15 December 1987 (illus.).

"Breverman's Art Work on Display at Miami." *American Israelite* (Cincinnati) (illus.).

Brown, Gordon. "Harvey Breverman: FAR Exhibition Review." *Arts*, March 1974, 70 (illus.).

Burnside, Madeleine. "New York Reviews: Harvey Breverman (FAR Gallery)." *Art News*, Summer 1979, 178.

Cafesjian, Gerard L. "West '80, Art and the Law." *American Bar Association Journal* 66 (July 1980) (illus).

Canton Art Institute Annual Report, 1987–88 (cover illus.).

Carnegie-Mellon Magazine 9, no. 1, (Fall 1990) (illus.).

Chmielewski, Tom. "Remarkable Variety of Art for Area Show." *Kalamazoo Gazette*, 9 February 1997, E5.

Comerford, Ellen. "Breverman Show Pleases." *Niagara Gazette*, 22 October 1989, 6 (illus.).

"Corcoran Biennial Selections Go on Exhibit at FSU Monday." *Tallahassee Democrat*, 22 September 1963.

"Corcoran Biennial Show to be Exhibited at USF." *Tampa Florida Tribune*, 14 July 1963.

Crowther, Hal. "Breverman Traces Life in Memorial." *Buffalo Evening News*, 1976.

Emerson, Roberta Shinn, "Abstract Art Predominates in Galleries Exhibition 80." *Huntington Herald-Advertiser*, 10 May 1959, 24.

Exler, Elizabeth. "Society of American Graphic Artists 65th National Print Exhibit." *Journal of the Print World*, Winter 1994, 8.

"Exposicion de dibujos contemporaneous Norteamericanos." *Tiempos Nuevos* (Moscow) 24 June (1973) (illus.).

Falkenstein, Michelle. "The Nightworks Series: Works on Paper by Harvey Breverman." *Hadassah* (New York), May 2002, 55.

"Familiar Faces—About Memory: A Selection of 20th Century Portraits, Ball State University Art Museum." *Muncie (IN) Star Press*, 16 February 1997, 4E.

"Federman Cycle at 92nd St. Y." *Jewish Weekly* (New York), May 1997.

Findsen, Owen. "Exhibit Demonstrates the Art of Teaching." *Cincinnati Inquirer*, 3 September 1987, C12 (illus.).

Finkelstein, Lydia. "Existence Pondered in Breverman Exhibit." *Bloomington Herald Times*, 16 September 2001 (illus.).

"Focus on figures." *Tristate*, 6 September 1987 (illus.).

"Forgey, Ben. "Washington: At Jacob Ladder's Gallery." *Art Gallery* 16, no. 2 (November 1972) (illus.)

Fortunak, Mary. "Portraits on Display at Museum of Art." *Daily (IN) News*, 19 February 1997.

Frank, Peter. "Exhibition Review: Harvey Breverman." *Art News*, April 1974.

Gatewood, R. P. "Harvey Breverman: To Where the Gesture Flees." *Traffic East* 1 (January 2001): 27–33, 79 (illus.).

Genaur, Emily. "New Talent in Printmaking— 1965." *New York Herald Tribune*, 19 June 1965.

Gerrit, Henry. "New York Review: Harvey Breveman (Nardin)." *Art News*, December 1980: 200.

Gold, Barbara. "Harvey Breverman: Drawings and Prints at the Ferdinand Roten Galleries." *Baltimore Sun*, 9 October 1966.

Goldman, Judith. "The Print Establishment II." *Art in America*, n.d.

Greco, Simon. "Impressive Silvermine Print Show." *New Canaan (CT) Advertiser*, 1971.

Guitart, Manuel. "Minigravats fets a tot el mons exposen a Cadaques." *Diari de Barcelona*, Dissabte, 20 August, 1988.

Harrington, Barbara. "The Well Organized Genius of Harvey Breverman." *Buffalo Courier Express Magazine*, 14 July 1974, 6-9, 24-25.

"Harvey Breverman Art Goes on Display Saturday." *Miami Report*, n.d. (illus.).

"Harvey Breverman at Babcock." *Antiques and the Arts Weekly*, 25 May 1990.

Heavisides, Martin. "Harvey Breverman at Gadatsy Gallery." *Artmagazine* (Toronto), February/March 1979.

Hieronymus, Clara. "Harvey Breverman at Middle Tennessee State." *Knoxville Tennessean,* 20 October 1974.

"How Text Paper Adds Dimension to Graphics." *SYNTHESIS.* Mohawk Papers (New York), Cover and Text Paper Manufacturers, 1968.

Huntington, Richard. "Western New York Show Critiqued." *Buffalo Courier Express*, 22 March 1981 (illus.).

———. "The Big Impact of Drawings, Nina Freudenheim Gallery." *Buffalo Evening News,* Gusto Section, 26 February 1986 (illus.).

———. "Review: In 'Metier and Mirror' Harvey Breverman Takes Reality and Expands It." *Buffalo News,* 6 October 1989, 29.

———. "Conjecture on What the Countenance Masks." *Buffalo News,* 20 April 1994, B6 (illus.).

———. "The Endless Search: Coming to Grips with Evil." *Buffalo Evening News,* Gusto Section, 16 April 1999, 2.

———. "The Federman's Fate." *Buffalo Evening News*, Art Chatter Section, 21 May 2000.

———. "Blown Away: Print Explosion Rocks the Albright-Knox." *Buffalo Evening News*, Gusto Section, 29 September 2000, 18-19.

Hutchins, Jessica J. "Works on Paper by Harvey Breverman at the Nina Freudenheim Gallery." *ARTVOICE* (Buffalo), 13–26 April 1994, (illus.).

"In Western New York 1981 Opens March 13." *Albright-Knox Art Gallery Bulletin,* March 1981 (illus.).

Inglehart, Robert. "In Breverman Art, the Figure Reigns as King." *Ann Arbor News*, 19 November 1978.

Inglis, Grace. "Back to the Drawing Board for Breverman." *Spectator*, Hamilton (Ont.) 3 October 1981.

Jarsky, Paul. "Toronto Exhibition Review: The American Image." *Brock University News,* 25 November 1976.

Josephs, Susan. "Ethereal Canvas." *Jewish Weekly* (New York), 20 June 1997, 17.

Kim, Kyoung. "Memories of Davening." *The Forward* (New York), 28 March 1997, 8.

Kirkwood, Marie. "Best of Youngstown Show Now at Circle Gallery." *Cleveland Plain Dealer*, 11 October 1962.

LeBrun, Carol. "19th Annual Boston Printmakers at the Museum of Fine Arts." *Boston Sunday Herald*, April 1967.

Levine, Linda. "An Artist Interpreting His Art." *Buffalo Spree* 14, no. 2 (Summer 1980) 52–61 (illus.).

Lewis, JoAnne. "Exhibition Review: Jacobs Ladder Gallery." *Washington (DC) Star and News*, 25 October 1972.

Mack, Tom. "Human Figure is the Subject of Twenty Years of Study." *(Aiken) South Carolina Standard*, 2000.

"Members' Gallery Presents Work by Harvey Breverman." *Albright-Knox Art Gallery Bulletin*, September 1989 (illus.)

Metzler, Paul. P. "Youngstown Butler Exhibit Opens Today." *Cleveland Plain Dealer*, 1962.

Miller, Donald. "Butler Show Celebrates Pittsburgh's Own Harvey Breverman." *Pittsburgh Post Gazette*, 1997.

"El Minigrabado Internacional Sabado." *La Vanguardia.* Guia de Exposioiones, 7 January 1989, 29.

Muck, Gordon F. "Harvey Breverman in Recent Show at the Schuman Gallery." *Syracuse Post Standard*, 17 November 1963, 15.

Myers, Fred. "Breverman Exhibit." *Grand Rapids Art Museum Bulletin*, December 1976.

"Mystery of a Prayer Shawls Series at Milton Weill Art Gallery." *Arts Jewish Journal* (New York), 21 September 1990.

"National Invitational Exhibition." *Hawaii Tribune-Herald*, 31 October 31 1985 (illus.).

Netsky, Ron. "Harvey Breverman on Display." *Rochester Democrat and Chronicle*, 5 June 1988, 3D (illus.).

———. "Technically Superb Work Reveals Portrait Subjects' Personalities, Attitudes." *Rochester Democrat and Chronicle*, 4 November 1984, 30 (illus.).

———. "MAG Show Features Challenging Drawings." *Rochester Democrat and Chronicle,* 1988.

"No Short Cut for Nardin." *Artspeak (New York)* 2, no. 7, (31 July 1980).

Olmstead, Anna W. "Breverman Exhibit Reveals Skilled Artist." *Syracuse Herald-American*, 22 March 1964, 4.

Phillips, Joan. "People Painter Breverman Keeps It Plain and Simple." *St. Catharines (ON) Standard*, 6 April 1972 (illus.).

Piper, Frances. "Columbus Gallery of Fine Arts Art League Exhibition." *Columbus (OH) Dispatch*, 1961, 3.

Preston, Stuart. "Printmakers at AAA." *New York Times*, 19 June 1965.

Reeves, Jean. "Breverman Using Grant to Pursue Theme of Realism." *Buffalo Evening News*, 20 November 1962.

———. "Harvey Breverman of UB to Have First One-Man Show." *Buffalo Evening News*, 11 November 1964, 54.

———. "Breverman's Sequences Deal in Fragments of Experience." *Buffalo Evening News*, 4 November 1970.

———. "Intensity of Excellent Prints Was a Shock at First Glance." *Buffalo Evening News*, 12 October 1974.

———. "New Breverman Work: Artistry of High Order." *Buffalo Evening News*, 8 n.d.

Rhea, Tom. "Spiritus Mundi: A Glimpse of the Divine at the SOFA Gallery." *Bloomington Independent*, 20 September 2001 (illus.).

"Renowned Artist Will Visit Ball State." *Muncie (IN) Star*, October 1999, 199.

Rowes, Barbara Gail. "Upstate's Compulsive Artist: Breverman of Buffalo." *Rochester Democrat and Chronicle Upstate Magazine*, n.d.

Rubell, Ellen. "Exhibit Locks into Baseball." *New York Newsday Weekend Magazine*, 16 February 1990, 16-17 (illus.).

Sakel, Sassona. "The Figurative Scene at the Galleries." *Artspeak* (New York) 3, no. 3 (9 October 1980) (illus.).

"Samuel Beckett Good Friday Birthday Tribute." *Hallwalls Contemporary Art Center Newsletter*, April 1990 (illus.).

Secrest, Meryle. "Six Printmakers at Fendrick Gallery." *Washington Post*, 6 September 1970, 68.

Seidel, Michael. "A Bunch of Swingers." *Art News,* May 1990, 41, 42.

Shamp, James. "Seeking Reactions Intent of Artist Breverman's Works." *Kalamazoo Gazette*, September 1976.

Shapiro, Cecile and David. "Conserving the Printmaking Tradition." *Art News,* March 1977, 51–54.

Singer, Clyde. "Realists Lead Parade of Winners in Midyear." *Youngstown (OH) Vindicator*, 1962.

———. "Butler Galleries Hold Exhibits Sure to Please." *Youngstown (OH) Vindicator*, 2 March 1997, D7

Smith, Virginia Jeffrey. "Buffalo Painter in Schuman Show." *Rochester Times-Union*, 19 November 1963, 9B.

Stahl, H. J., "Printmakers at AAA." *Park East* (New York), 24 June 1965.

Stersik, Tom. "In-Depth Study of Art by Breverman." *Kalamazoo Gazette*, 26 September 1976.

Talbot, Jarold. "Huntington Gallery Annual Exhibition." *Huntington (WV) Herald-Advertiser*, 30 April 1961.

Teres, Rosemary. "Exhibit Three: Small Shows Good." *Rochester Times-Union*, 15 April 1970.

Townsend, J. Benjamin. "Eloquent Graphic Explorations on the Albright Gallery Show." *Ethos*, 23–24 (illus.).

Uhles, Steve. "Go Figure: Artist Has Subjects Just Sitting Around." *Augusta Chronicle*, 7 July 2000.

Van den Briele, Luc. *Graphia* (Mechelen, Belgium), 1996.

Voell, Paula. "Check Out – Diamonds are Forever: Artists and Writers on Baseball." *Buffalo News*, 14 May 1992, B1, 3.

Walrath, Jean. "Figure Dominates Art at Schuman Show." *Rochester Democrat and Chronicle*, 26 August 1962.

———."Harvey Breverman's Errors Raise Eyebrows." *Rochester Democrat and Chronicle*, 24 November 1963, 12W.

———. "Two Faces are the Same, Because . . . They are the Painter's." *Rochester Democrat and Chronicle*, 17 March 1963.

Willig, Nancy Tobin. "The Lively Arts: Harvey Breverman." *Buffalo Evening News*, June 1968, 52 (photo.).

———. "Breverman Better Known Elsewhere than on the Niagara Frontier." *Buffalo Courier Express*, 2 April 1972 (illus.).

———. "Breverman Prints Proof of Artistry." *Buffalo Courier Express*, 17 October 1974 (illus.).

———. "Kenan Center Exhibition: Drawings Are Elegantly Detached." *Buffalo Evening News*, 20 April 1976 (illus.).

———. "Breverman's Works Reach Pinnacle of Technique, Style." *Buffalo Courier Express*, September 1977 (illus.).

———. "New Breverman Exhibit to Open." *Buffalo Courier Express Magazine*, 18 September 1977, 25.

———. "Review: One-man Show at Nina Freudenheim Gallery." *Art News* November 1977.

Winebrenner, D. K. "Breverman Has Versatile Talent." *Buffalo Courier Express*, 14 May 1967.

"Yeshiva Museum Exhibit Focuses on Prayer Shawls." *Paper Pomegranate* (New York), Spring 1997, 9.

EXHIBITION CATALOGS AND BROCHURES

Adelman, Meri. *Personal Myth/Historical Memory: Breverman, Cohen, Kedem.* Philadelphia: Philadelphia Museum of Judaica, September 18–December 6, 1992 (exhibition brochure).

Bayliss, George V. *Harvey Breverman: Recent Paintings and Drawings.* Ann Arbor: Jean Paul Slusser Art Gallery of the University of Michigan, November 1–21, 1978 (catalog preface).

Berreth, David. *Harvey Breverman/ Draftsman/Painter.* Oxford, OH: Miami University Art Museum, August 22– October 11, 1987 and Canton, OH: Canton Art Institute, November 22, 1987–January 3, 1988 (catalog interview).

Bryant, Edward. *Graphics '68: Recent American Prints.* Lexington: University of Kentucky Art Gallery, January 14– February 11, 1968.

Cathcart, Linda, and Douglas Schultz. *In Western New York Invitational.* Buffalo, NY: Albright-Knox Art Gallery, March 26–April 17, 1977.

Colby, James D. *Harvey Breverman/ Nightworks: Metaphor and Memory.* Jamestown, NY: Forum Gallery, Jamestown Community College, October 4–November 1, 1997 (brochure statement).

Cole, Sylvan Jr. *Breverman: Selected Works, 1964–1971.* Canton, OH: Canton Art Institute, September 12- October 3, 1971.

———. *New Talent in Printmaking.* New York: Associated American Artists Galleries, June 14–July 2, 1965 (brochure introduction).

———. *Harvey Breverman: Selected Graphics 1970–74.* Buffalo, NY: Gallery Without Walls; Boston, MA: Impressions Gallery, October 16– November 16, 1974 (catalog preface).

Creeley, Robert. *Breverman: Artists, Writers, Musicians, and Others: Works on Paper.* Buffalo, NY: Nina Freudenheim Gallery, April 9–May 11, 1994 (brochure preface).

Cumming, Glen E. *Harvey Breverman: Recent Paintings and Drawings.* Hamilton, ON: Art Gallery of Hamilton, September 10– October 11, 1981 (brochure preface).

Featherston, David. *Commitment to Vision.* Eugene: University of Oregon Museum of Art, 1986 (catalog introduction).

Federman, Raymond. *Breverman: The Human Presence.* New York: Nardin Galleries, September 23–October 25, 1980 (brochure preface).

———. *Harvey Breverman: The Federman Cycle (A Portion Thereof).* New York: Milton Weill Gallery, 92nd St. Y, March 31–May 8, 1997 (brochure essay).

Fischman, Lisa. *Landscapes from the Permanent Collection.* Buffalo, NY: University at Buffalo Research Center in Art and Culture, January 22–March 17, 2000 (brochure statement).

Fradin, Joseph I. *Harvey Breverman: Recent Paintings and Drawings.* Niagara Falls, NY: Buscaglia-Castellani Art Gallery, Niagara University, April 13–May 20, 1984 (catalog essay).

———. *Breverman.* New York: Babcock Galleries, April 20–May 18, 1991 (catalog preface).

Freschi, Bruno. *Megalopolis.* Buffalo, NY: State University of New York, 1993 (catalog statement).

Goley, Mary Anne. *Artists Who Teach.* Washington, DC: Federal Reserve Board Gallery, October 13–December 11, 1987 (catalog essay).

Goodman, Susan T. *Jewish Themes/ Contemporary American Artists.* New York: The Jewish Museum, June 12–September 12, 1982 (catalog introduction).

Greaver, Harry. *Breverman: Selected Works 1964–71.* Canton, OH: Canton Art Institute, September 11–October 3, 1971 (brochure preface).

Greaver, Harry, Benjamin Townsend, and Kirk Newman. *Breverman: Painting/Sculpture/Graphics/Drawing.* Kalamazoo, MI: Kalamazoo Institute of Arts; Grand Rapids, MI: Grand Rapids Art Museum; and Muskegon, MI: Hackley Art Museum, 1976–1977.

Herskowitz, Sylvia A. *Drawings and Prints by Harvey Breverman: Mystery of a Prayer Shawl Series.* New York: Yeshiva University Museum, March 16–July 31, 1997 (brochure essay).

———. *Harvey Breverman, The Nightworks Series: Works on Paper.* New York: Yeshiva University Museum, March 14–May 26, 2002 (brochure preface).

Jarzombek, Nancy Allyn, and John D. O'Hern. *Realism Now: Traditions and Departures—Mentors and Protégés,* Boston, MA: Vose Galleries, May 17–July 17, 2004 (catalog essay).

Kotik, Charlotta. *Works on Paper: Recent Acquisitions.* Buffalo, NY: Albright-Knox Art Gallery, April 3–May 20, 1979 (Introduction).

Kotik, Charlotta, Susan Krane, and Douglas Schultz. *In Western New York Invitational.* Buffalo, NY: Albright-Knox Art Gallery, March 13–April 19, 1981.

Krane, Susan, William H. Gredts, and Helen Raye. *The Wayward Muse—A Historical Survey of Painting in Buffalo.* Buffalo, NY: Albright-Knox Art Gallery, March 28–April 17, 1977.

Morsberger, Philip. *Harvey Breverman: The Figure Concealed and Revealed.* Augusta, GA: Gertrude Herbert Institute of Art, June 29–September 7, 2000 (brochure introduction).

Schneider, Claire, and Kenneth Wayne. *Rembrandt to Rauschenberg, The Norton Print Collection.* Buffalo, NY: Albright-Knox Art Gallery, September 28–December 31, 2000.

Smith, Selma, ed. *Printworld International Inc.* 7 (1996–97).

Soltes, Ori. *Realm Between Realms: Histories Between History.* Washington, DC: National Jewish Museum, August 14–October 15, 1997 (catalog essay).

Taylor, Stephanie L. *Harvey Breverman, The Nightworks Series: 40 Works on Paper.* Bloomington: Indiana University School of Fine Arts Gallery, September 4–October 6, 2001 and Athens: Ohio University Art Gallery, January 8–26, 2002 (catalog essay).

Tillou, Dana E. *One Hundred and Fifty Years of Portraiture in Western New York.* Buffalo, NY: Burchfield Center, December 9, 1981–January 31, 1982 (introduction).

Zona, Louis. *Harvey Breverman: A Retrospective.* Youngstown, OH: Butler Institute of American Art, March 2–April 20, 1977 (brochure forward).

PUBLICATIONS FEATURING THE ARTIST

Beake, Fred, Wolfgang Gortschacher, James Hogg, and Thomas Hartl. *The Poet's Voice,* New Series, No. 4.2, Salzburg, 1998 (cover illus. and three illus.).

Broun, Elizabeth, Smithsonian Institution. *The Norma Lee and Morton Funger Art Collection.* Luneburg, Vermont: The Stinehour Press, 1999: 80, 81 (illus.).

Callnan, Patricia, and Tom Butterfield. *The Masterworks Bermudiana Collection.* Hamilton: Bermudian Publishing Company, 1994: 230, 231, 232, 233 (four illus.).

Falkner, Thomas J., Nancy Felson, and David Konstan. *Contextualizing Classics: Ideology, Performance, and Dialogue: Essays in Honor of John R. Peradotto.* Lanham, MD: Rowman & Littlefield, 1999 (illus.).

Gordon, Peter, Sydney Waller, Paul Weinman, and Donald Hall. *Diamonds are Forever: Artists and Writers on Baseball.* Washington, DC: Chronicle Books and Smithsonian Institution, 1987 (one illus.).

Hartl, Thomas, Douglas Rice, and Larry McCaffery, eds. *Raymond Federman: A Recyclopedic Narrative.* San Diego: San Diego State University Press, 1998 (cover image).

Hays, David. *Today I Am A Boy.* New York: Simon and Schuster, 2001 (cover illus.).

Knigin, Michael, and Murray Zimiles. *The Contemporary Lithographic Workshop around the World.* New York: Van Nostrand Reinhold, 1974 (one illus.).

Malone, Robert R. and Ying Xue Zuo, eds. *Forty Contemporary American Printmakers.* ChangChun, China: Jilin Fine Arts Publishing House, 1998 (four illus.).

Mendelowitz, Daniel. *Drawing.* New York: Holt, Rinehart, and Winston, 1967, 256, 331, 332 (one illus.).

Myer, Peter L. *Art: Do It: A Handbook for Artists.* Dubuque, IA: Kendall-Hunt, 1996 (four illus.).

Ram, Michael, ed. *Fragments of Science: Festschrift for Mendel Sachs.* Singapore: World Scientific Publishing Company, Pte., 1999 (15 drawings).

Schulze, Franz, and G. L. Cafesjian. *The West Collection: Art and the Law.* St. Paul: West Publishing Company, 1986: 66, 67 (one illus.).

The Writer's Craft. Evanston: McDougal, Littell, 1993 (one color illus.).

Tseng, M. Therese, ed. *Raymond Federman and French Marginal Writers.* Baltimore: American Literary Press, 2002 (one prose piece, cover illus., and 15 illus.).

CHRONOLOGY

1961 Commences teaching affiliation with the University at Buffalo, 1961-present. Promoted from Instructor to Professor, 1961–1969.

1962 Butler Institute of American Art 3rd Painting Purchase Award, first work to enter public collection. Joseph Butler buys second painting, later donated to museum.

1964 Attends opening of Corcoran Biennial under patronage of Mrs. John F. Kennedy. Painting hung between Edward Hopper and Rico Lebrun. Exhibit travels extensively.

1965 Lives and works in Amsterdam as Resident Painter at Royal Academy.

1966 Working visits to England, Belgium, France, Spain, and Israel.

 Visits Poet Peter Redgrove in Leeds (Gregory Fellow) and draws him.

 Meets with print curator Elisheva Cohen at Israel Museum.

1968 Attends opening in Amsterdam of "28 Hedendaagse Amerikaanse Grafici," with other US representatives Richard Florsheim and Sylvan Cole. Show travels to Germany.

 Begins bronze relief series (sponsored by the Upjohn Company) in anticipation of exhibition "Seven Printmakers as Sculptors" in New York and San Antonio.

1969 Visiting Professor at Illinois State University (Summer).

 Visiting Artist at Falmouth School of Art, Cornwall. Travels and works in England, Wales, and Greece, mainly Crete (October–November). Travels and works in Israel (December). Begins friendship with Michael Rothenstein in England and makes several drawings of him.

1970 Begins first lithographs at Boston's Impressions Workshop and makes periodic working visits for seventeen years. Meets Hyman Bloom and Fritz Eichenberg.

 Participates on panel discussion at Metropolitan Museum of Art, "Art History and the Studio," with Wolf Kahn, George Rickey, Louis Finkelstein, and Ed Wilson.

 Grants panelist, New York State Council on the Arts (C.A.P.S.), with Tony Smith, Dore Ashton, Jacob Lawrence, and Ben Fernandez; also in 1978 with Louise Fishman, Robert Moskowitz, and Leon Polk Smith.

1971 Meets with Gabor Peterdi after Silvermine Guild, CT, solo show.

1972 Joins FAR Gallery, New York, and is included in group shows.

 Travels and works in England and Israel (December).

1974 Visiting Artist at Oxford University's Ruskin School (also in 1977) and included in three-artist exhibit at city's Museum of Modern Art. Panel discussion with Pat Gilmour. Studies old master drawings at Christ Church College. Attends Norwegian International Print Biennale and is on panel in Fredrikstad. Meets Anna Breivik and is invited to Atelier Nord.

Meets with Gerd Wohl, curator of Munch Archive in Oslo. Visits second Munch Collection in Bergen.

Juror for Rutgers University National Drawing Exhibition with Richard MacLanathan and Jacob Landau.

Lectures at the Baltimore Drawing and Print Society and is Visiting Artist at the Maryland Institute College of Art.

1975 Visits with Edwin Dickinson at Wellfleet and makes several drawings of him.

 Joins Gadasty Gallery, Toronto.

1977 Travels and works in France, using Avignon and Nice as base. Visits museums in Biot, Cimiez, Albi, and Montauban, with specific interest in artist's working drawings (March–May).

 Visits Holland and Belgium and meets with Simon Levie, Director of the Rijksmuseum.

1980 Joins Nardin Galleries, New York, and has solo show.

 Draws Tom Wolfe in New York and on subsequent occasions. NYC transit strike prevents photographer Peter Fink from documenting the drawing process; instead artist is photographed at Dakota Hotel.

1982 Begins series of drawings and pastels of Michel Serres; attends his lectures and produces many working drawings that develop into larger works.

1983 Travels and works in Venice, Seville, and Cordoba (September– November). Draws Vincent Price in Piazza San Marco.

 Returns to commence work on NFTA Subway Commission funded by NEA.

1984 Travels to Switzerland and Israel (May).

 Meets with Zurich Print Archive curator Dr. Reinhold Hohl.

 Visits Thyssen Collection in Lugano, Winterthur Museum, "Am Romerholz," and museums in Bern and Basle. Produces many drawings and watercolors.

1985 Grants panelist, New York Foundation for the Arts (NYFA), with Ed Colker, Krishna Reddy, and Michele Stuart.

1986 Beckett Series commences; corresponds with writer at urging of Raymond Federman. Series exhibited in 1990 at Hallwalls Contemporary Arts Center.

 Draws the writer J. M. Coetzee prior to his departure for South Africa. An etching is created from the drawing series.

1987 Awarded Ohio University National Alumni Association Medal of Merit for Notable Achievement in Art.

1989/90 Mellon Foundation Seminar Leader in Drawing for nonart faculty in six Virginia college consortium (June).

1990 Lives and works in village of Cadaqués, Catalonia (September) in connection with solo show at Taller Galeria Fort. Dali's relatives attend opening.

Juror for 10th Mini-Print Internacional. Visits and works in Barcelona, Girona, and Sitges. Joins Babcock Galleries, New York and is given first of two solo shows.

1990–93 Travels and works in Bermuda (January), producing a series of watercolors. Bermudiana Masterworks Fund acquires five works from Babcock Galleries for the National Gallery of Art.

1992 Travels and works in Switzerland (June). Visits museums in Lugano, Mendrisio, Zurich (Bührle), and Basle (Jewish Museum)

1993 Juror, Brigham Young University, "5th National Biennial Drawing Exhibition."

1994 Travels and works in Prague with visits to Terezin (May–June). Draws Prague native, opera singer and Holocaust survivor Karel Berman. In Paris draws Lionel Prejger, Picasso's long time sheet metal fabricator. Visits museums in Dijon.

Distinguished Visiting Printmaker at Kutztown University, PA (July).

Travels and works on landscape series in Israel (December).

Begins Federman series.

Awards Juror, Audubon Artists Inc., "52nd National Exhibition," New York.

Awards Juror, National Academy of Design, "169th National Exhibition," New York; and again in 1998 and 2000.

1995 Visiting Artist in Drawing (July–August) at Pont Aven School of Art, Brittany. Draws several of village's prominent citizens; four drawings are acquired by Galerie de la Poste.

Expands Nightworks series begun during Virginia Center Residency.

Draws Karel Appel and develops etching from it.

Drawing of Dwight Macdonald acquired for the National Portrait Gallery and The British Museum acquires a work for the 20th Century Drawing Collection.

1997 Delivers Elsie Rosefsky Visting Artist Lecture at State University of New York at Binghamton.

Conducts monotype class at the Kalamazoo Institute of Arts and is juror for their regional art exhibition (January).

Jagiellonian University Exchange Scholar, Cracow; affiliated with Institute of Contemporary Art History. Visit is cosponsored by the Cracow International Print Triennial Society (May–June). Produces many drawings that fuel the Nightworks series. Visits museums in Zürich and Zug.

Invited to draw and document at Symposium: "Fragments of Science: Festschrift for Mendel Sachs." Participants include two Nobel Laureates.

1998 Appointed Advisory Board Member, Ohio University Kennedy Museum of Art.

1999 Appointed to the rank of SUNY Distinguished Professor by the Board of Trustees, State University of New York

2000 Lectures at Gertrude Herbert Institute of Art, Augusta, GA

Panelist at the Albright-Knox Art Gallery, "Perspective on Prints," with Kenneth Wayne, Aprile Gallant, Deborah Ronnen, and Antonio Martorell.

Juror at Columbia College, MO, for "22nd National Paper in Particular," and delivers lecture, "About Drawing."

2001 Attends Chancellor's Awards Reception (with poet Robert Creeley), State University of New York, Albany, honoring Scholarship and Research in the Humanities, Arts, and Social Sciences.

Participates in the Dorit and Gerald Paul Lecture Series in Jewish Culture and the Arts at Indiana University, with writer Amos Oz and art critic Michael Kimmelman.

2002 Panelist at Albright-Knox Art Gallery, "Recollections," in connection with Edwin Dickinson exhibition. Other panelists are Douglas Dreishpoon, Mary Abell, and Michael Mazur.

Expands series of engraving made from life drawings and notes to include Robert Pinsky, Elie Wiesel, Daniel Libeskind, Christian Pregent, Michel Deguy, J. M. Coetzee, Philip Roth, and Allen Ginsberg. Among

the visual artists included are Sigmund Abeles, Jim Dine, R. B. Kitaj, and Ernst Wille.

2003 Receives the College Art Association's 2003 Distinguished Teaching of Art Award.

Delivers lecture, "An Obsession with Drawing," at the National Academy of Design, New York.

Juror for "Contemporary Drawings 2003 National Exhibition," T. W. Wood Gallery and Arts Center, Vermont College/Union Institute.

Delivers lecture and conducts class at the Makor/Steinhardt Center, the 92nd St. Y, New York.

2004 Works in Bermuda (January).

Conducts research at the Centre for Whistler Studies, University of Glasgow.

Makes several drawings of the writer Edwidge Danticat and the poets Joyce Carol Oates and Johanna Drucker.

Painting Awards Juror for "179th National Invitational Contemporary Art Exhibition," National Academy Museum, New York, with Benny Andrews, Jane Freilicher, Irving Kriesberg, George Nick, Philip Pearlstein, Paul Resika, and Miriam Shapiro.